Some People Fall in the Lodge
and Then Eat Berries All Winter

Also by annie ross

Pots and Other Living Beings

Published by Talonbooks

Some People Fall in the Lodge and Then Eat Berries All Winter

POEMS AND IMAGES

annie ross

TALONBOOKS

Talonbooks
9259 Shaughnessy Street, Vancouver, British Columbia, Canada v6p 6r4
talonbooks.com

Talonbooks is located on xʷməθkʷəy̓əm, Sḵwx̱wú7mesh, and səlilwətaʔɬ Lands.

First printing: 2022

Typeset in Minion 3
Printed and bound in Canada on 100% post-consumer recycled paper

Interior and cover design by Typesmith
Cover illustration and endpapers by annie ross

Talonbooks acknowledges the financial support of the Canada Council for the Arts, the Government of Canada through the Canada Book Fund, and the Province of British Columbia through the British Columbia Arts Council and the Book Publishing Tax Credit.

Library and Archives Canada Cataloguing in Publication

Title: Some people fall in the lodge and then eat berries all winter : poems and images / annie ross.
Names: ross, annie (annie grace), author.
Identifiers: Canadiana 20220284105 | ISBN 9781772014396 (softcover)
Classification: LCC PS3618.08255 s66 2022 | DDC 811/.6—dc23

Our Lives, Held in Trust (how to read)

to for with in all every Living Being/s
one you together apart intermingled
Righteous Relationship Responsibilities Rights
to Life's Lives, more than Survive – Thrive

Indigenous inherent Rights, Rights of Rivers
Rights of Land, Rights of Mother Earth
Hold me as i Hold you

inter-dependent, inter-change-able ability
personalities, work, Star paths, and Long Counts
wants, needs, Six directions of Infinity

i die with your death with out you
seriously, life is, loses its
gleam, mean, i won't live without don't want to live
without Giants, Ghosts, Spirit Beings

Relative Relation Ghosts sights sounds
(i) give Love and Thanks
Love and Care for all Beings

Divinity in a Handful of Water

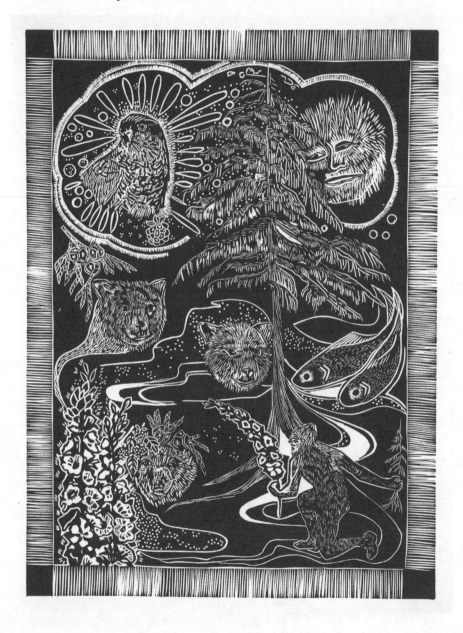

handful, 2021–2022. Relief print, ink on paper, 18″ × 24″.

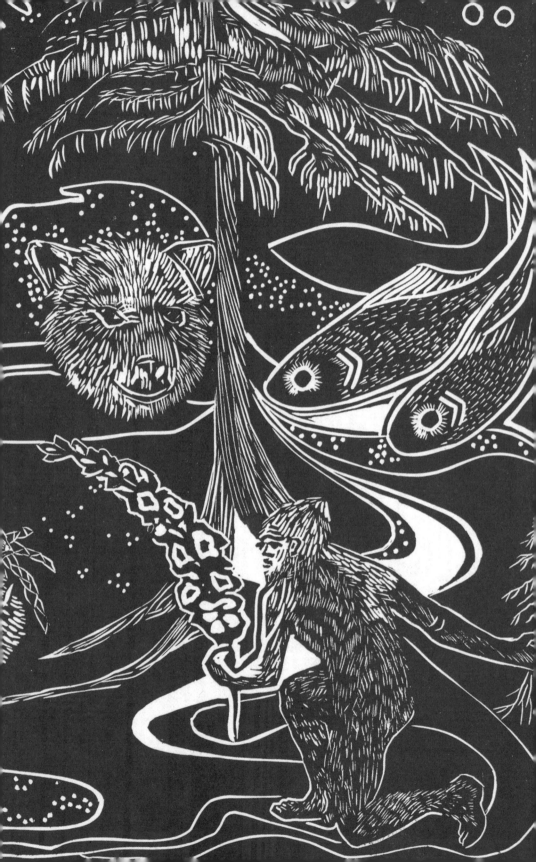

Hero

he is standing, puffed chest
in the breakdown lane of the interstate
winds from cars as they flee from, gather to
he fluffs his Feathers, Orange as a Sunrise, a Lily
eye Shine at Night

his left arm is frozen and splintered open and up
i gasp. his Work, taken by metal, fossil fuel
meaningless rush. can't we be more careful? can't we
see enough to wait, pause, get out of the way
do no harm

your face to my face has left me without air
heavy-stomached, dreadful, this feeling of death
i start to stop, to wrap you in swaddling clothes
as we did a Hawk in California, poisoned, made well
here, Washington, another day for you to be hungry to fulfill your
path, your Mice, your family
i must take you to help

as i pull over, i see him in my rear view
he struts straight into the foray, the noise, the heat, the smell of
certain endings
i watch him walk past one car, then is seen
no more

my arm is broken
i have been held from lures, traffic
told this, the best manners in a mannerless
time. if i had only been as courageous
none of this later life would have been felt if i
had just walked in

Home

Watchers, Land Defenders, Food Planters
Ceremonies
hairy ferocious Mamas and babies at the upper reaches
where God/Creator/upon Whom you may believe
lives alongside Creeks who flow Water where we all
drink Freely, Cold life entering and inhabiting
every bit of you and i, awakened

i can't bear the thought there's a place where
it isn't possible to walk into a woolly Goat, an arctic
Mammoth, while daydreaming watching setting Sun
as Sun says goodbye and hello as we do
hello, goodbye

isn't it the most natural thing in the Earth and Sky to look for
our BeLoveds, to share a bit of Root, to sing together in
language of our deepest Dreams because no
one can hear us, we are atop Land, under Water
atop Water, Under Land and from someplace
keep it all

ii. fight extinctions

deep knife shooting gun vanquishing
will taken, desire dissolved, re-Made place where there is no way ahead

where is Thunderbird House, DayShine sightings?
a massive Bird who soon shall emerge from a Land, south
will fly, answering, soon
i won't can't shant be far gone from
Butterfly House where humans re-Make re-call
re-join Hold fast fantastic Spirit Beings

Wild, Sacred, Good (Vine Maple)

Deities, icons
bodies, molecules
a universe, in parts, internal mandalas
walking as a Buzzard flies
Eons who are Veined skirts of Mountains
please

i laid my forehead on the Ground every Four steps
knowing all along that trail
running is beautiful, as i could Fly
i was counter-clock to their clockwise
Prayers, repeats
no one knows what lives in my head
circling high, round and round Granite
haláẁ Golden Eagles

falling Water songs are meditations, field guides
a quiet mind, i do not possess

i have walked lifetimes to see you, pounded Amaranth, Corn
open Yellow Sunflower, Rosehips, Juniper Berries, my Prayer beads
i count, as you count
a piece of Bread in a loaf, a Potato in a field, a glass of swirling Water
your face, an Eternity
falling, Floating

from sovereign Places, Oceans, Seagulls flock
downtown, in search of Love, a way away from canada
scattered Toast, torn apart, lying about, as we, in our
heat, hunger, thirst

how many interpreters do i need, a chain of translators
for protruding wrist bones that will not heal

Salt Woman cascades like a fall, rests as a Lake, dries as a sheet
precious Snow, Sacred jewel
every twelve years, every twenty-eight years
every 3,800 years, i pass
you pass
Candles, Leaf-wrapped Loaves, Flowers, Stones

together with Magic

any where any biosphere
any House, Home

Magic is the wrong word, there is no word
which instructs, supports, recognizes
Those, Them, Their, Our

x, we shall say, when thinking of those rendered imagined
Impossibles. into the Woods, under Water, over it all

Hold my hand
hard, tight, bind me close under cloaks
Feathers, Fur all of You
don't let go

hard-hearts big-heads say – You don't exist
they deny You – past present future it's all the same
Soul, Spirit, Phantasm, Ghost, Power, You
You, who rush out as simply
easily as a heavy-winged Heron
is mirrored, meets, the Universe reflected, held by Mudflats sinks
a nearly Frozen Glacial Stream, brings more
Food Flowering, then making Seed

ii. ride

we ride Winds together, passing past any bodily
concerns, we, as unmanageable ones, recall Love's
first incarnation
hello this
our binding

Holy Beings live, where
alongside those who are as they are and
forever shall be. Ferocious, gentle, smarties, necessary
so Fantastic we call them, mythic, legendary –
no, right here, right now
i have lived every moment just to
glimpse our turning of We

iii. a poem by an Owl

Whale and Birds, you hollow-bones, your pitted-boned
bodies, arms the breadth of Ocean Gulf Mountain Valley
You Named, Seen, Danced, Dreamed
painted with Sun, Red Ochre, Fat
alive/suspended upon/along sheer draping Cliffs

is this my body, fallen, under a massive Fir
felled?
no – my Soul, having left, returning

iv. return

more than a Miracle to see you, Caribou one, Caribou Herd
hundreds (thousands) of you ran past me as i stood on a
northern Glacial River plain, so close as to warm me as your
energies flowed, Gravel Rain

i stood, you flew. i, inconsequential to your Migrations
to Birthing Grounds, the most any human may offer
every Wild Run

Faith is a Seed in the belly of a Wren
it is Shit, it is Rain, it is all who make this paper, your mind
a Just world is possible

when ■ and i travel, the group of us, our
compatriots follow, lead, witness
Air, Dirt, Water, Rock. we accept our fate
we Walk, Spore-footed
Rhizome-Planters, source-Breathed
hello, great Grizzly
growing life-Maker, your Food our Food

four-thousand-year-old Understory
boreal Forest, knowing you live is Blood's beat
all is well and right because you are Here
my life shortens as Tree Fern Berry limbs crushed
graveyard Tree tomb Stone stump You are every Where

at high noon, a desolate, bombed desert
highway Tarantula
larger than tumbleweeds, darker and wider than truck tires
skitter across in a way that speeding cars seemed to
disappear. i was momentarily blinded – the world went blank as if a
blanket thrown over my head

i see You
i saw You
we are Together, again

every Where every time all day

state of Grace (how to be absolutely certain)

Blue Butterfly, pesty Blackfly
arm in arm
set upon my lips
shiny tooth tongue gloss reminds them
Soul energy in Flowers, Moss, Mushrooms

that of
those to
mix with
what will be blanket Fogs, Wet Air
Aquifers, Ocean swells, swimming
Peaches and other Honeyed lives

our bodies, we Branches, our circling
ambulating Clouds
inner Valleys, outer microscopic Galaxies
between Shimmer Dust who are
Cosmos in the middle of a Bee foot

Sun opens vastly all over while fitting between spaces made
from long-Needle Pine embracing Wood Limbs
heavy with Cones, Seeds, Dew
our Glittering lives, as Lakes
Sparkle

our many-coloured Bloods, our many-field of Glows
our pieces grasp one another, we Fasten
fit tight as magnetic North, South and the Power flowing in between
Euphoria

Land is a state of Grace

port land or any vancouver

bearded man, oily jacket carries history
deposited upon sidewalks – old coffee in damp paper cups
bits of grub in crumpled wrappers, footprints of Pigeons
war witness, empire's leftovers, hungry mouths

in the act of scattering Bread i Witness Holy host communion
someone said feeding Bread to Wilds is abuse
many days, b/Bread was all i had/have and here
we all are

his blanket confirms many weeks past, present
tomorrows place of Rest
what do you see, as i in my hermitage
and those in the Trees anxious for a bit of mangled baked wheat

large slices, baker's pride sail in Spirals through
near-freezing Rain onto city Ground. cars at a stoplight
windshield wipers, wet clothes
Mud holds Rain, neither willing to let go
both changed, Water is Mud, Dirt is Mud
Bread, body of Lives, Eucharist, Bird Food
atop. we see this Miracle of met basic needs
the last i have, i give

Pigeons, ecstatic Yellow-eyed pacers race walk
for that belly-full answered Prayer for Food. seeds, only ghosts
vanquished. they mutter thanks and Ecstasy, those bitty beaks
gulping joy as i, we, feel the fullness
Happiness from those every needs
we all here, this Esoteric revelation

i am picking my arm nervously, they
sharp-beaked, pecking Bread
our Pigeons' Sainted provider has
miles to walk

ode to Golden Spruce

Golden Spruce is a landed
tidbit roaring Lightning held hold BeLoved
changed changer, inside out and upside down
Dazzler, shining with BeLoved Earth, Her Rains, Her Fish
dazzling elegant Every One Glisten Glow
get up, get out, Flash – You Hold Place of Miracles, Birth, Rebirth
fulfilled basic needs of all Living Beings we are all alive

Breathe in, out our Sacred Dance of
inter change able ity
arms branched limbs under flashing lights
broken air boom Earth turns, Star blink, a partnered Eternal
code, playbook, outlasts chainsaw afterburn, climate change Flood
neoliberalism's imagined ruin, real, then a leftover
tragedy for tomorrow's youth
endless sorrows, you wipe those tears

Golden Spruce Forest multiverse, birth life under-storied
Wild sovereign, blood lines, Roots, and
other above below Celestial trails
Eternal Return is You and Yours

cry out in the Night, darling
he/she can/may occur any here, there, every Where
but chose seclusion. isolation. segregation from human
machines, empire, colossus. our safety is by being left lone
transformed un-attainables live among along
quiet locales where legends
buzz, drench, flow, tingle, crawl

many-specied prophets, sages know knew
our Spirit Bundle of give-and-take would someday
fall into the wrong hands

resist! recover, re-Sanctify
Knit Weave Build them all back together forever

Thunder Being Power

compatriot with/for underground Uranium
Earth Being searches upward
moves below Plant world, the other flying towards BeLoved

they meet, they are the Sun of Night
Earth vein Rock vein River vein, Water – always Water
bring alert create make
from outer reaches, where red is no longer Red
they find one another, burst, embrace, our hair on end, our nerves a-tingle as
Spirit
rushes up our down and out to Eternity

cure for sore Frog feet, Wild Horse hooves healed
Peaceful

until

ii. climate disruption

someone imagined burning us all, gathered others to burn we all
uranium-plutonium blast, unnatural forest fires
the flight from Home, the flight from Merritt, the flight from two hundred
island Nations
again, again until no Home, no Home towards
Whom to flee. there is no place in any imagination to settle
nuclear waste, climate ruin, sacrifice zones

fallen house. from SuperNatural Sacred Earth to
Memory, Myth, Legend; Sleeping – an underground, WindSwept, awaiting
Root
sprouting of Seeds, hatching, nest-making, and expanding Wombs
how can you help? visions inhabited with Caribou
Herds, Grizzly Bears, Mountain Goats
hands follow dreams, imaginings, hopes

abolition. Restoration.
dirt-making, dam dismantling
for all Beauty Beings Dreams Justice Eden Home
sweeps, surrounds, brings, takes
Waters run, fall, emerge, meander
we live, believe, give forever in all
Wild our perfect SuperNatural made/make Homes

i know what's Real

our World is Indigenous
no paper doll, no plywood imposter may
be our magnificent
Old Growth Dance Star Power
sorrow's overburden, nuclearism's heavy water
all i may offer is an aching gaze, numb
dumb, as in
death, where is thy sting

as if Summer Cats, lounging in golden streaks
Ghosts linger upon a sun-filled settee
forever near
always i leave tidbits of Food
upon my dinner or Garden plate for/with all of You:
 may there be enough for the Living and the Dead
 past and forever
 come and eat

ii. cardboard cut-out

a cardboard cut-out of a cop points a speed gun as if a gun
at my head. he greets me every day as i Pray for Peace on my
drive to work
the police will kill you, he says
he does not know me, my name, my Blood
my Ruin he ruined
he points massacre at our heads, hearts
we who Never agree, surrender

our Hero God, Creator, Mother, Holy Being, Saint
congregation of million-year-old Prayers, Dances, pilgrimage of Stars
map-making, Planting – we every single one and all
refuse to duck, stop, lie down

mounted photos, life-sized puppets, the man
from the mine imagines remediation after the mine
offers a plywood mural of Forests in place of
our beLoved Guardians, dwellers of the
Womb of Mother Earth
he says, *this copy will be exactly the same as*
not a replica of, and here we may place our laments

iii. resist!

in brilliant spaces between Constellations
my skin is that of an Elk
upon resting from extended family's run
walks into a Cool Stream, reborn
B'ak'tun counted as are Songs from Wolf, Howls and Smatterings

we know Who is Real

costume contest

humble old man who is not a man but an original Being
we never say his name aloud so never mind
an elderly man who is a human said he dresses in tattereds and is
covered in Dirt
his face is that of an Angel if the angel is terrible, frightening
Fierce

you think too much about him, calling him close
he rattles the doorknob, shows you how he turns to Fog
enters through a crack beneath the Wooden door
you try to leave but the door is bolted
from the outside
Night until Dawn he plays children's games
until your hair turns white and you decide never to return

who is You, Fire-Maker, Life, Death Life Bringer
sweeper of Dust, Cleaner, so many tasks
you show up during the hardest
just so i can stop feeling so very much
alone

ii. monster face

old manners, Original Instructions, First Beings
run over by a big rig, highway expanse, pipelines
mounds of papers
genocide's efficient bureaucracy

windmills to the left
oil tanks, railroad tracks
to the right

i forgive myself

Joshua Trees are tired of all of this
back and forth
Desert Tortoise, GrandFather Toad, know
righteous action

iii. feed her now

three-legged Cinnamon Bear walks upright
empty cookie wrappers entice her with their
smell, a promise of Food

her Web, her den, her stomach
empty, empty. i am heartbroken and shall never recover
until She

now on two legs she walks
right arm limp, broken, in half
mend her arm, fill her pantry full
She depends upon you to do all right thought, right action, right livelihood

cohabit

you and i, snug as a Bug
our Corn Field HoneyBee Ant Hill rug

primate gathers Crystal Sand, Sparkling like snow
Summer heat, atop insect Homes, mounds
fill Squash Rattlers, rattling
the sound of Sacred Creation

never empty, because of You

Sing among Air, Water, Spirits, Clouds
beyond before ahead behind
Lightning hears, Shakes
under Ground under Water Cave
place of rest
fills Sky

hands, Paws, Claws, mitts, and fists
fill, Cure, calm

all i Dream, do, with You
our inter-being inter-change

citizenship

my Blood is Red, Black, Clear, Yellow
it is dried and wet Glacial debris
it is the sorrow of Suffering and the want
for Peace
for all Beings to Be

your metal cuts, burns, turns
us equally all inside out
my pain is your pain
none greater lesser than

Water Sky reflect out from our eyes hearts in the same
mirror manner
see in one another
our co-Whirling

speak Freely with Animals, Insects, Skies, Mountains
a Mole Hill, underground Rabbit hostel
Everyone responds
can you hear Them you may

beads in my Rattle are Rocks, Seeds, Stones
beads on my dress are glass, whittled
ḱátlaż
without this named and Holy place Home, we Shatter
as old gift-wrap joy embrittled by Sun

do did we ever exist, unless we
saw see be Make for
my your Water, Salts, Proteins
her husband's name meant "the Protein in Wild Meat"
Land Defender, Fish Stream Keeper
we make our way with Thoughts, Dreams, Imaginings
you we Belong as They Belong

perhaps we eat one another, perhaps sometimes we
flee those with an overenthusiastic Embrace
but we lie together as well

my Fur warms your Skin
your hands both Gather and Plant both sweet and
bitter roots
our shared interdependent children Elders insects

Relative, Relation, Responsibility, Ghost (meat no meat)

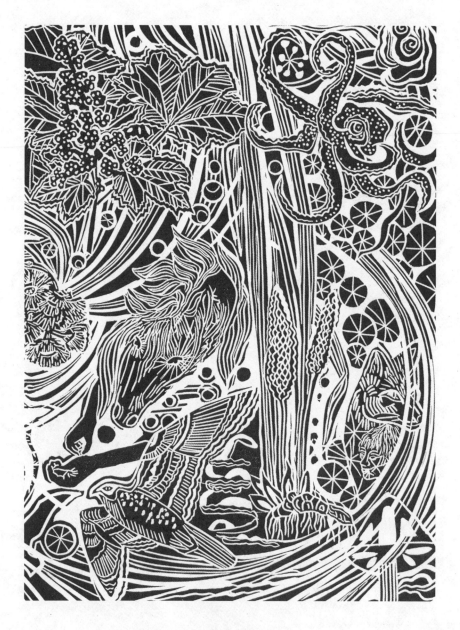

swirl, 2021–2022. Relief print, ink on paper, 18″ × 24″.

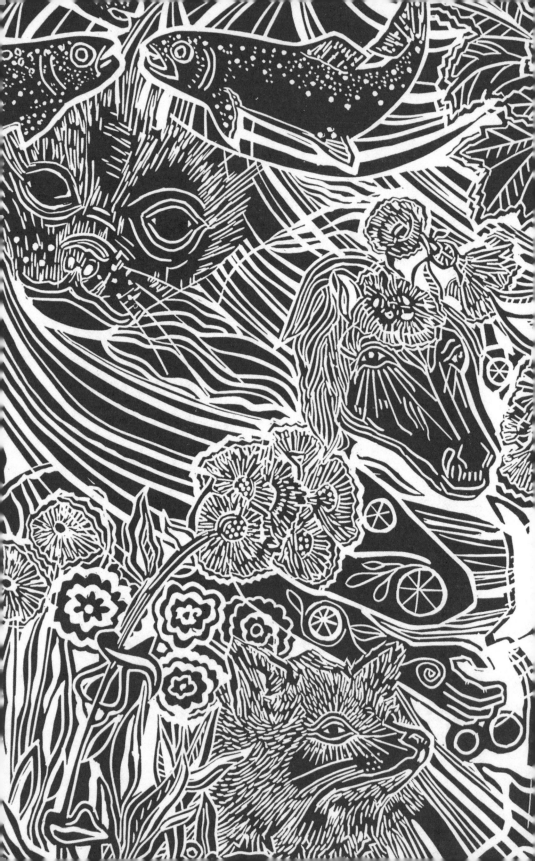

what

the Stars, bars, cars, liars
where did she go, why did she die
we needed her

Rick wants to learn the outline stitch
i want to make a robe, Cold Ocean gritty Salts
i am sitting in a sweater as Cat couch-Sleeps

i walk in hard Rain, my neighbourhood Ravine Bear eats Berries
city says, call us, about my
Apple eater, so they may kill kill kill

Bears and humans so similar, save for the one who is
a murderer

ii. who (your favourite kook)

dry paper temple, Bamboo cloth tattoo
math, mechanics, meltdown

enough to scare the world into MADness
enough to melt twin towers

iii. why

dance of the Red sandal moccasin barefoot
movements to Whom we dedicate our lives
those who take our lives Relatives, Relations, compatriots
hungrily, always hungry. there is no end to need so i get out of bed and
get to work

practice, performance, obsession, surrender
prima ballerina's Spider-web tutu
enfolds, enraptures, ensnares, endures

engineering's miracle expansive bridge lures with her
closing off of disappointment
Holy Water, Doctor Water, polluted Water
yet, Clouds pull in push out still Sacrifice to become Rain

iv. when

grandmother embracing her painted sign
grandfather speaking from the cold, hard Ground
claustrophobics gather together, fears burned up in the Sun
for this Hero's fight, give it all we got

Mothers circumambulate Holding a bucketful
of gichi-gami ᏢᏓ�577 (Lake Superior)
highways find a new use, they now moccasin paths
camouflaged Deer in tall Grasses and Fobs offer
Holy Hope activist acts so for
now everyone

v. where

inside heart's Hallowed hollows
Animals, Birds pilgrimage to family memorial grounds

knocking, whooshing inside temples
obliterated Atoll, army bands, Snow-capped test site Newe Segobia

Earth Mother
Breaths can't enter in and out fast enough
Springs so clear and strong Pearls adorned Trees

wedding

she leads a smitten pet who carries an Evergreen branch, blown
down from today's Wind Storm, rocking our cars
we strangers idle at a traffic light
Rain hits, darkening day, enlivening tall Cedars
whose arms wave to Spring, arriving
this could be us

our Earth's many Feathered Souls fall from
a thirsty Sky, drinking in. glass buildings take millions every year
we all know someone who did
jump

convenience foods, Plant-Parent poisons, we
regal Butterflies and Honeyed Bees
in this, starvation time

big Puppy's trotting legs are in the lead
his face expresses teenage exuberance and
confusion at his too-quick clip-clop
i think of runner Ruthie who now may only
saunter to the corner
then sit down

they three cross at their go which is my stop
a woman bounds from the corner house
happily, hurriedly. the door, pushed, waves back and forth
eyes Shine as they see one another, all Four
thrilled, enthralled in their lovely loving Winter day
we others, in heated cars, wipers beating
stare straight ahead waiting
our novella reveals where is it, we can possibly go?

where are you? i need you
if i Plant Seeds now, will you Flower in time for
Pollinators, Dream Bringers, the turning of many unpredictable turns

they meet at the Garden gate, she opens as her arms unwrap
to enclose one another
they laugh, the Dog smiles
baubles, candy canes, popCorn strings for our branch
who now is a Tree

road test

nothing seems tragic anymore since we
drove on well and
so very long and far past Sadness

not a town but a patch of three or four dwellings
who Twinkle little Star
five or six lights from their
distant, plowed-over, Water-starved space
signalling interstate, interStellar, passersby

hours outside of a Home who used to be called Hope
i recall those years i cried, heaved, suffocated for my world
the years i would break, when i still was able

windblown scarf from the top of a bridge, bigger
than life, these former skills
today, i turn away

stumps, remnants left behind from the logger
tombstones never laid for these, school children, Majestics
a Tree felled in the Forest,
everyOne becomes hotter, under-Watered, doomed

the border is closed. the border is wide open
not one car in the five-lane possibility
quiet sky sits still, empty overhead

today i drink sweetest shakes, Chocolate coffees
eat pickles and chips, look out of car
windows, racing shifting Clouds
we part company at the mystic Lake where
Rainbows and Swans gather

when? the last migration of Blue Whales
when again, the Skies full

Orca

canoe, as if an open hand
in repose, at rest, facing Shoreward. Grasses bend about
doing their best, wrapping, autonomous, they smell coming Snows

Mother Bear and babies, their long Sleep, their
hunger, our hunger
their Fish guts for Gulls and other chattering folks
Fish heads and carcass parts are set out on a sand
tablecloth, their solemn perfect selves
never forget – Eat, Share, Offer

there was a time we said to never allow
Land beings to meet too much with Ocean folks
and vice versa, as our worlds are in Power
then, the canoe dreams and does, somewhat as does Orca
riding Waves, jumping, making Sea Spray
showing off Barnacle belly skin

Shamans live apart
Medicine Man said, we never shake hands, we never say hello
we never think of one another
it is too dangerous
how deep? this Land, this Sea, this back Bay

please don't mind the mortality of
Kelp's footed anchors, Freely entangled by Otter Lovers, meditative
waving Urchins, Prayer flags made of many-
coloured mini-stone Food minerals who
float, as if without weight
put weight upon the largest
of Earth spectacular, Whales, Penguins, Albatross

float, dance, dream – passing Clouds turn Light
to Dark and back again, why is my Shadow
so long? why is my shadow so small?
Stratosphere Current, Wind Whirlpool
Horizons mix. no up, no down
hold, hard, these
we may regret or embrace
our Death, our Life

ii. ocean-going tree

he cut you down, BeLoved
you risked it all when forcibly
floated down River to the Sea

may i come down from my Nest, once in your safety
your calm, your Heaven Branch
i will live with you
beneath weighed Waves
your House, your Home
you, in your Glitter species shift shroud

i say, come back. i want to say
come back, knowing i am
wrong, to say
come back

all i want is
for You to live forever

iii. Heron

open Heron arms, Heron minds, Heron
eyes, open Beach calm bend Mud Nests
Whale belly-scratch Bay

it is noon, it is midnight
mirrors made of moving dark Clouds

low Tide daycare Crab kids, Horse
Clam babes, Grasses, Muck
broken glass welcomed, as they tumble tough to become soothed
polished by swirling, re-Made
able now, to join Chiton, Sea Cucumber gems

Moon Shines east alongside Day Light west
who grasps your hand, in encouragement?
you, who earn
your Names

hello, our Relatives
hello, our every Beings
when taken from Ocean, all colour, all brilliance, all sparkle
fades

if i Loved you one centimetre Centipede
Caterpillar more
it would be the end of me, or my new
beginning

as you
are made to stroke deep Seabeds
drink from Lagoons, bejewel Tidal Flats, Shorebird WetLands

come back, come
back

on gathering Tree Roots

Forest park
shredded
now silent ground

not a Maidenhair Fern
Blackbeard Berry Bramble, nor
creeping Moss patch, however small, not even a palmful in
which to imagine genies or Grubs
remain

mountain boots sigh, having awaited marvels from their cloister
where? our promised tumbling Glacial Cascade?
kin of flying joy?
a lone Flicker shows us her Orange-quilled wings

towering Tree into Soil turned, burned
handless grey chalk Dust greets remaining
Spores, Cones, Seeds
what can i expect of cities
humankind's urban wooded (woods)

humans fear Bears for their big hands
Centipedes for their skittish feet
rain for being Rain. they run from those who save
yet laugh, chortle, scream happily at hitting, the breaking of bones

tsvls Kingfisher, his hemispheric fluffed crown
her Riverbank uphill tunnel Nest
give glowing eyes to thick Root and Stump carcass mounds
i talk to King, but he will have none of it, with knowing scorn
has not my kind done enough?

i am not them
i am not them
i dress like them
i eat like them
i look like them
i am not them

this day, my Prayers go nowhere
stopping in the space outside my forehead
unable to fly

i feel Mourning all around
my words are dispossessed into only words

as Tobacco is placed for Revival, Roots i hope to salvage, to make into a basket
no matter Love and Thanks' pure intent
for once, this once
there is no reply

an engine hums
a truck beeps in reverse
someone closes the gate and i wonder how
to get out

ii. trenchers

we walk, counting days among fossilized Eggs
Seashells filled with Rock
human footprints embed, transform
days of wet soil, now, Sandstone
LegendTime's Seashore embrace, remind Ant people
who we were (gateways for Spirit, bulldozed closed)
Prairie Falcon's Nest of Sticks
Petrified Trees crushing yet, Coal

excavator's dinosaur-like track is the robbing of Earth memory
mystery, possibility, hope
today's Cloud Mud begins what will become, imagined fable
before Dirt is Stone, its Task already begun in
haláẇ Golden Eagle's Ancestral geologic memory

We are here
wish you were here
you are

bulldozers sit idle, as if unblemished. Withes broken into wheel wells
elderly *tsátawaoż* Cedar bodies, stacked with brood *púłtnaoż, tśq̓alhp,*
tśútśxlaoż Hemlocks, Firs, Yews
shattered limbs, Homes, all together
smell of fresh *pa'chäj* (Pines), Eternal Life
emanating from cut limbs

it will be Christmas soon, or at least
someday, sometime, will we be alive then?
remember all those broken years

iii. BeLoveds

Emerald Golden-aura Homes
wholly Haunted, with all Who matter
revered SuperNaturals alight my face as if firecracker sparklers
knock me out, sing me Songs, send glimpses of tomorrow

the more they come
the harder to remain human

language of ancient mystics, Fogs
habits of Ursa, Sky, Earth
pulling Roots

iv. instructions

be careful, there's Bears there, city worker warns
after i have already, *there*
they want my Food, not me, i defend
point the way to Freedom

humans ensure my hard hat, reflective vest
 prohibit Sanctuary
Power Beings see and tell, forgive too much
send dreams and colour schemes, still live
here you, here me
visitations dread-less, fright-less, Holiness
this Beauty Path

you, their mythic fiend
you, my BeLoved Blood
they spill yours, they take mine
i hide Apples in Stumps

our secret Passageway
Blackhole to Galaxies' Peace
Sacrifice
Kindness
there is no me
without You

Food stall

shovels spear into a mound of Ice
piling over there atop, in the act of
melting and keeping fresh flesh
inside this outdoor market

Ice-stained plywood stalls
standing room only occupied by food Who
are not Food. their families and forlorn
Ocean, being made more
lonesome as we, absent to our Sanctity

we Salmon, Sea Urchin, Octopi still with Soul
imprisoned, lame, atop shovelled Slush
slid onto metal scales, tossed as if footballs
by the gills

Halibut, *mámelt* Whitefish, perfumed yet with Life
and all the Lives of the Seas Slime Rainbow
as bright as a bundle of Green Leaf Sea Rose Bottle Nose
Sun infiltrates through open doors, windows
to Shine path, the Flight Home

Polar Bear rug shakes his head as if Star Dust
so as not to sneeze and reveal his lingering essence AfterLife
Dolphin languishes upon a dinner platter
she blinks, winks, intact. we have a plan, we smile
once and now still these Lives lived in Dreams, Visions, open air open to all
i see you, we say, close to death, and giggle
as they prepare to eat

even though i can't swim well
past the continental shelf
your bonds tether to my Freedom and we bound
through Waves, feeling, falling, floating, flying
we all unlashed deepest Ocean Sanctuary

all we seen as only Food
transformed into plumpy Silver bodies mirroring Sky
gathered as a swarm, swam out of a drowned
splintered Wooden fishing boat
Wood replanted, made Forest
every Being Freed

Boulder fall

within *scwákwekw* hearts' muscle
in – Obsidian, out – *twan* Salmonberry
blood in, blood out
Mountain face Stone gathering
tumble, slide, re-gather
my home, my Home

Stones' voices moan, shout, break, crack. bravo!
we stand in ovation, bow, empathetic
to now-open Minerals Amethyst Crystal made
Mole Mouse Ermine House
mini Mammal and Bird feet hop hurriedly
we give one another our
hungry understanding

as *q̓ápxwaoż* Hazelnut or any Tree is felled, every Heart of every Being
suffer, hears, sees, smells the chainsaw, horror
flee from the sight of lives forever cut, mangled, a huge jumbled mess
no Dinosaur-Ginkgo-Fern wanted
this obliteration, weeping obituary

Stream continues her/his/their Fantastic muscle-making rush
push-pull under mirror-calm surfaces, Dragonfly respite
Swimmers give Life, sometimes i have eaten them
making thus, us, their children's children
their struggle, their lives. houses and guts understand need, but not
wanton destruction

Night rises upwards from its mysterious other Destiny
where it has spent its day, Being what it needs for itself
empty without one anOther
Night is our time of safety, to travel, eat, live
hidden from empire

alongside day's departing stare
Stones held and give Sun where i shall Sleep among, atop
Needles, Branches, nocturnal Spiders;
sidewinding Rattlers, pocket Mice and Dust

Cold emanates from Ground
having waited many lifetimes for this
penetrating test
(it has only been one day since i have felt you, dear)

moving easily through clothes, Skin, Bone, to Marrow
bonded as Bark to Tree, mid-Winter wedded eve
i shiver as in this lifetime
my Fur is one tangled mat

tsátawaoż, ṗúłtnaoż, tṡq́alhp – Cedar, Hemlock, Fir,
sitting with singing Birds, resting from digging roots for babies' bassinets
Spirit Black White Yellow Red Bear walked from the body of an Elder Tree
Elder Tree – your secret doors, your Holy Spaces, your Sacred Truths

teacher said, *we won't be able to weave these much longer*
no more Old Growth Majestics from Whom to borrow long straight Roots
to swaddle our infants, make Our Lives Whole

daytime left over in a SuperNatural scene
daring, Shivering reverence
all other handed footed beings say
it is all right. Plant today
in four hundred generations we shall weave again
this, we Make

Albatross

another morning
i wonder about waking up yes or no should
i open or something
now what? i ask

look to you – who do everything round sunny bright
we both in Sleep, Fly
our Breath, our Wings, sketch Spirals in the Air
who then call in all Beings wet Breath Fog Mist Who gather to
be multicoloured sweeping Clouds

Albatross, many months you are open-armed
no rest over open Ocean Winds Who are one another
you – a solitary me – a hermit

Phytoplankton Sea Bloom families photographed
by satellites, recalled by floating Spirits and trance
Places where visionaries roam
at the deepest dark down, sink where few grow –
no Sun, no Sun
Whales dive, all the way, up and down between and
mix up nutritious Water, Food for the shallow-Water
dwellers. Our Rights, our Responsibilities for all to eat

Jellyfish blend endless Waves
Whales, Moon, our eternal Whirl, penetrates skins
Forests Deepest Water makes Air
Lungs, Spouts, Love and Thanks

Beetles, Ants, Ladybugs Work alone from Flower to Flower
we, beholden to Wind Waves Tides, eye Shine
how long can you hold
our Food, our Air, our Breath

your winged high-Seas Life is also
underneath many-branched Bushes
you Natural One, defy international law following our
Original Instructions

how can i make Love real, Honey
vast, remote, near, dear
amid human-made drones

after i fell aSleep (Orang) for Biruté Galdikas

heat-withered Guava leaves roll tight knowing it's a
Wait for a more Just era, coming
survive somehow, mankind's burning your Sacred Home

Ancestral manners, Orang's original instructions, Rights
Durian, understorey underfoot sky-filling Forest
Trees, Flowering Homes, Rooted Hopes

soldiers, palm-oil plantations
pillage, war, bakery, nut spread, orphans
a tattered flag twists to a rusting steel pole

wet Life, RainForest birth
burned canopy, commercial grease blown, machine-broken
palm oil, bitumen. no matter your form – your curse

during Dust-dry days, to escape searing scorched Earth
we Flee until we Fall
RainForest Sanctuary invaded guns, germs, croissants

Red-haired Beauties, under a Hoodoo wind-spell
witness vanishing of urgent tasks that made/make us, families, villages
ancestral primate bonds, bound
climbing, Fruit sharing, child rearing

we hold out our hands and ask you
yes you, to grab on, take Care, make Refuge

Limbs knot themselves into a living fence
Root bridges carry wants and needs
chattering, growth, turning

will i ever be reborn? and to where, pray tell
cars empty their tanks
freeways loosen bits of black, peeled by tires, wearing down

Come from Trees and Stars

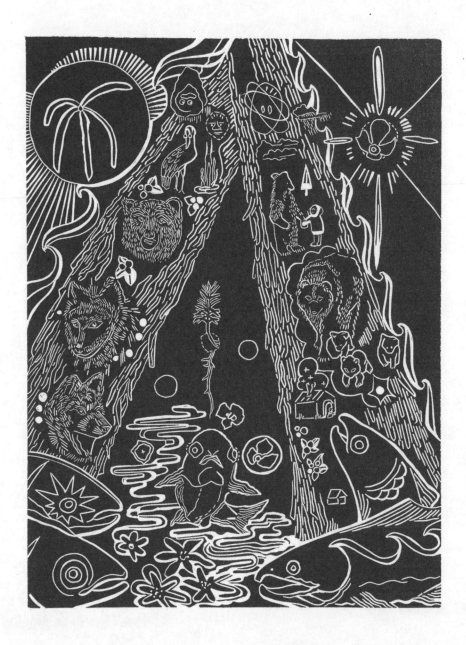

Cedar SuperNova, 2021–2022. Relief print, ink on paper, 18″ × 24″.

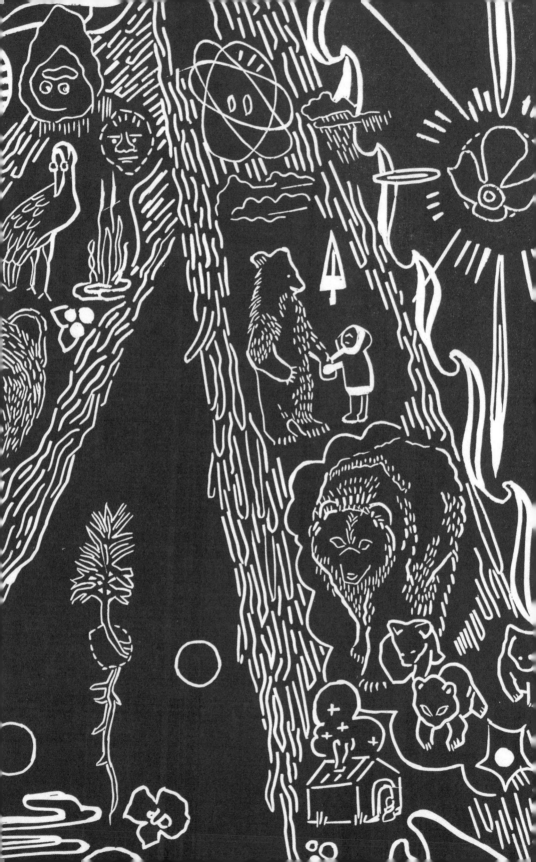

how to talk

hello i feel You i see You, here you are, as you have been all along
stop Breathe this Air smells like ash that Air smells of Spawners. Tidal Pools
smell as Life listen slow down. there are needs to be met

our kinds our Hearts may still meet this way, as They are open. Open up
your pain Life Love is mine
we meet through our Love for/with BeLoved Mother, Earth
the more we give away the more grows

i separated from my walking partner for only one moment
immediately You appeared, bounding high and pushing off
footfall oomph, Pine-scented dry Soil Storm
our collision felt as a soft brush, heat, smell from your body
penetrated, lingers still

i say this as if it is happening now
i think of Her and She appears
would you like to have some, shared?
just ask, kindly give back, times ten

Wild ones are Free, full
unashamed of their smell, how far fast they Run
snort and kick, her Grace Shines
we find Rivers by looking for stands of Green

dry Leaves rush, rustle, airborne now
i smell her Stream nose and mouth, Ionic breath
she is with child; this a visit from
Our Lady of Sequoia
Love and Thanks to you, dear Mother

ii. *don't go there*, he said

i sit internally quiet, diverse songs from Insects brief visits
beneath are a gathering of perfect high-humped Bears made of Stone
warming, soothing Boulders, coming heavy Snows
talk of Give and Take

a Bee bumbles Flower heads
she needs them more than i
a cloud of White Butterflies Flutter

hand-high from our cool Ground
together, bundled Love for sweet, cool, abundant Water
we drink together and share this opening of
our true selves

we are something other than this human, brittle shell
when this body goes
i return to Deer, Butterfly, Grass, and Springs

how to visit

she brought over a Mountain Goat wool shawl woven by
my friend of decades. *it sheds too much*, she said, draping it over my
shoulders, stooped. i love it, i need it, hello
dear Frannie, thank you for all of the grrl talk how
you understood my/our womanly griefs, grieving, Seven Sorrows

we weavers. Frannie handed me Cedar bark to strip, many arms long
how could she trust me with such a treasure? my hand shakes, her little smile.
we made Christmas ornaments, baskets, watched the Tide and she said, *i was
born on that little island* pointing with her face. her days were those where the
Tide set the Dinner table
this day three Mallards hung at her doorway upon a twelve-penny nail

Cats and Dogs shelter rescue
tidy or matted, aSleep or awake, feet run
dear beauties, despite our empty houses
they are gassed

in the high country, i search for bundles left by itchy Goats
Spring sheddings, scratched off on Stones, Branches, dried hard Lichen patches
many Birds nursery baby blankets – your worthy mission
soothe the newborn Nest full of open mouths
Worm, too, appreciates his cozy final bed

in my house sticky tape – rolls over cotton, rolls over wool,
rolls over thrift-store finds, the couch awaits her turn
vacuum revs his engine, overheated
White-and-Orange hair, stuck in a tube
i need a rest. sit
outside, tufts hop up in Spring's hot air
escapees! Free to be Fruit blossom hangers-on
Spruce Bud decorators
Wind-Winding dancers, a Raven grabs you, mid-flight
River floaters

it's me. i have done it
must be kind to Animals
never expect steak
mind the Bees and Bears
in our Garden

how to talk to more-than-humans

when we meet another, in our varied Fur, Fluff, Slime, Skins
our tragically wonderful
in Love, full of Love, Heartache

do you know when they we last ate, made plans for tomorrow
had big Love for and by
do you even wonder how to Help
make it all Work

were you chased down an alley
by a man with a knife or
off a Mountain by a man with a gun
our Love does not break apart, our Love Holds Hard
binds, knits, knots

drowned in deluge or thirsty, burned, hopeless onslaught
no, modern life, i do not submit. no, climate disruption, i sing to rising Sun
i am Planting fields of baby Trees who will be thousands of
years old. my Ghost shall fly over their heads and we will do say
we imagine ourselves into Being
hands hearts make Justice Real

weapons of mass destructions
lost souls only brought you here to bring us back to our
Original Instructions. there are laws already here for every Living Being
violate: consequence

walking aware, Caribou tells his story, in his/her language
last, lone survivor, yet fulfilling Creator's
hopes from the Beginning
how does the machine that ruined you save
you, as you try to save
Land? you bolt from me, and although i want to meld
you are right
to Run

You belong in your Herb-Flower-Medicine crown
bellyful Ecstatic state
Star Fire Hematite, migratory sun-darkening diverse flocks
air full of Fliers and Songs of those
we recognize, and those from the LegendTime
original Roots, Skies, first Shiver, first steps walk
upon Sacred Mother Earth

Ermine chases you through
Rock-tumble Dens, a brilliant Sea Star whose colour
flees as her Life Force
goes, we are as old as
Imaginings, Dreams, Knowledge

you may feel panicked by the Black
Bear Sleeping beside you, no need. you
may please do can feel perfectly at
rest, as one, be assured

now is knitting itself onto forever
put it all back together
it is our Work from the very first to
the very last

how to cure loneliness

tiptoe across melting-Snow street
i ask for a lonely companion to appear

Slush finds her way, entering easily into my shoes
she is unmoved by me but makes me, her – cold, wet
friends are themselves Winter Streams

wet car exhaust darkens my wool coat
proving oil will never be clean
i do not belong here

ii.

i prefer fresh yesterday's Toast with hard cold butter
dairy Cows suffer. i am to blame
my era of excluded morning, midday Foods
Fly sat near, asserting his Raspberry-jam dreams

together in a Salmon stream, Bears and i
we are Kittens who coo and swipe
when it seems i can't Love you any bigger or better
i do

lesson plan

to a Fly, i wonder how my liver
appears, apart from her humid amiable
domicile, she
is enticingly luminous, bloody
soft as silk, hard to chew
brought into being by thoughts
of a mass of Worms in their
entrusted above and underground
MotherLand

i wonder how my hairy head like a woolen hat
appears to Someone Flying
fluff, a Sheep's former clothes, yet responsive to Wind
brings forth a nearsighted Raptor
he grabs with sharpened Claws
there are children at Home
open-mouthed

i am not a Mouse
nor a meal but if i were
it would help

foundling

Squash Woman's portrait illuminates
an underground Desert Temple, smelling of dried Sage
ancient Snakes pecked onto Rocks

Ocean Valleys, Prayer Bowls, Blue Whales
a lighthouse laments Lichens
through blinding Fog sending out welcome warnings

Caves inside us vibrate, as in the very Beginning
every Hand Heart Hold Held Open sounds like
Crystals in Gourd Rattlers

ancient migratory memories, Earth's Blue Whale
i am a bit of Crust littered
from the heel of Bread

i am not sure about numbers as one billion Feather-bearers per year
are fooled, flying into skyscrapers reflected Sky
no one taught us
television's morning drone drowned
out Sunrise Birds' Collective Medicines
as massive Sky-migration Miracles flew overhead, sweeping
we cheered our teams instead

it's hard to hold our Breath or to Breathe enough to
understand needs, wants, desires, regrets

our last reaches are reachable
and this i Mourn

Be Invincible
(bioweapons, disruptions)

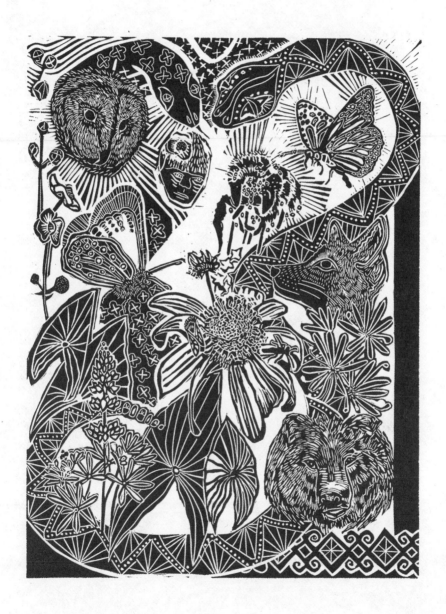

Hero Twins, 2021–2022. Relief print, ink on paper, 18″ × 24″.

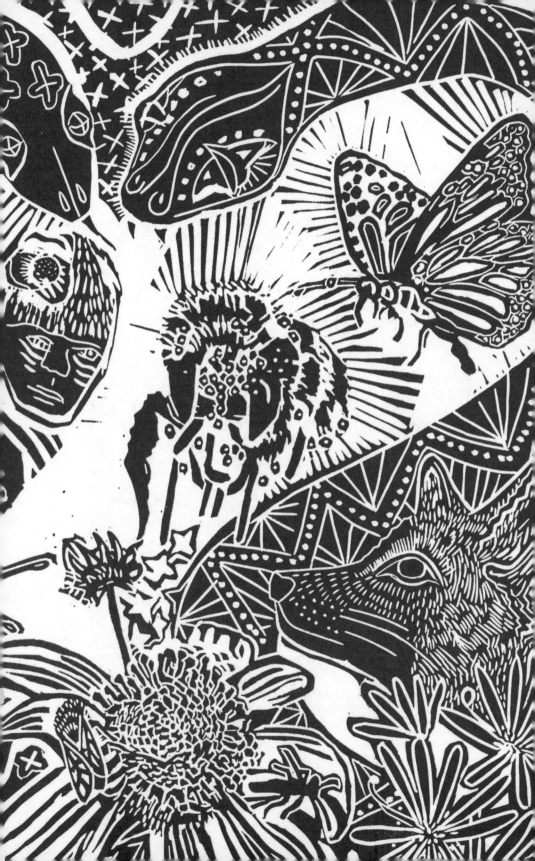

war is epidemic (for a former smallpox village)

we all ate from that same Camas Potato Corn Squash patch
none of us had more to share than our
common grave

we lived with numb shock again again again from
BeLoveds' deaths over and over no matter how much we ached

stunned, meditative, silent as River Boulders contemplate
Saturn's Dust bands, each believing in the other
as all else, seemed to fall

told to live into, beyond, to walk through our
moments and years of hard Mourning
with sickness all around (deadly, that) we thought of
Mud, Clay, Dirt, cool and safe above and below

farms, Elks, our hearts soared out from this living
to visit the World of the Dead
we looked deeply together, Held hands, as Mists held
and let go, becoming a Watery Eternal Embrace

in the Daylight, when we saw one another Sleeping so restful, calm
we would Rattle, startle –
are you aSleep, dear Mother? thinking she was – but
no. dead tired, though
what was it Louis had said, two days before?
i am so tired i could Sleep for a week
how i Mourn him

who can worry about world war when one rages here
they with their guns, uniforms, prime ministers, presidents
dewatered former Lakes

i stand at the Stream as she licks Mud and Grass Roots lovingly
as i lap Mud and run Leaves over my tongue for Water
so hot, this fever
a new disease, another in the litany, as if a book
of war

Johnny, my Johnny's Uncle carried his
Frostbitten Brother over Three Mountain heads
to Home. don't stop. never Stop
three days, thirty below, socks for boots

all is well here we are

Graves, dug by heavily, gently
moving stacks of Rocks
good night, dear Mother
good day, dear Father
songs, arrows for young sons, daughters
needle kits, dances for our baby daughters, sons

Pika, Mouse, rousted from Dens
they and their White-Flower headbands
Roots worn in spaces between teeth
chatter, squeak Ceremonials
They held Vigil with us
our Hands clasped as if Holding
Sowbug, Earthworm
BumbleBee, a Berry, or tomorrow's grand Life

GrandMother took fermented Clay, a bit of
Fish Oil, a Licorice Fern, bundled
we held on to these, our jewelled candies
between skin and fabric
we all drink our Sacred Water
Protected this way

i can't give up
(Land Defender's history lesson of the spanish flu)

for Yaqalatqa7 (Johnny Jones)

our doctors, healers, our very best were done away with
we had only ourselves, we left behind, upon whom to rely

we come out of it
everyone scared of it
afraid to help those who did have it

ii. testimony

strangers invade
their filthy bodies, bearded faces, covered in
greasy clothes
we saw them walking along our ridge
dragging large sacks

we watched them, their faces, their hands
but forgot them when
called by Compatriots Whom we Live among
Leaves, Howls, Night Bears, our Lodge, our Hearth, our Home Here

soon after they arrived, fever came into our
havens, acting as if
hungry for the marrow
in our bones, tunnelling

we became still as if trapped underground
between geologic faults
immoveable with ache, ached by immobility
unconscious for four days and four nights
as have been our Prophets, but this was not a Sanctified Being

iii. now

did we come from Stones, Fire, Stars?
as we spent all our time
with Water, shelter, our children, wandering Birds and beLoved Beasts

much time passed before we spoke together of our fevered visions
we thought deeply of what we saw

with Clouds

some Where every Where
many all total every
want wish need a drink of Water. it's You

today tomorrow forever
this place holds Peace Goodness Virtue

ii. burden

Rain Home, chainsawed clear-cut
the same way you hunted extincted my Wolf Family
Rain is not your pest, Coyotes not your pest, all we are allowed is
to obey your oppressive flawed intolerance

between outside and in, dear Land Sky, Life Death, you made me *desaparecido*
to Whom shall we turn when the need to Howl in
Greeting, in Prayer, in Sacrifice
breaks you as you break thousand-year-old Cedars

panic heart desperation, eternal Mountain calm
heat record smashed by twenty degrees, up
heat in my chest, Cold of the Lake, fires every all Where
Sheep died standing, saliva dripping from their hung-head mouths
over six hundred humans dead in this city, paramedics going from one
body to the next

iii. beyond clear-cuts

Light transparent Beings
i touch this *tśatśú* Wren, Spotted Towhee, Bear Hand
beyond the place of Mountain climbers and deep-Sea divers
past Prayer flags, solo Hermitage
no longer notable concrete crumbles, Mould emerges
(our only Safety, in being too far) Who lives here, the last
remaining of that kind, Prophecies are a mirror
reflecting destruction, chaos, world wreckage
mirrors break, seven years of rebuilding

you Red, White, Yellow, Black Cloud Dream for this Planet
you keep moving – solid, vapour, liquid, sweat
you float, fall, become invisible, evaporate before hitting Land

you see all, know all
your Testimony, in Hurricanes, tidal Waves, rising Oceans
swamped Homes

every day forever different, never the same as one past
here, there, transforming to make Miracles of now

we made a hole in the Ozone
as if we didn't want you to stay
Stay. my guilt was handed to me
i erase it with work

Her Ghost stops at Nothing

Andrew's on the phone in the living room with
sister Linda, recently widowed. we three at the dinner table
it makes me a bit sick to recall
i contemplate Dust in corners as if sweeping, guests chew

Gordon (is this is his real name?) turns his
chair to stare. if it wasn't my home, i would leave
he pontificates – energy, auras, an accelerator in Geneva
spinning time sun sets will there be Squash in the Garden this season or shall
perpetual heat burn

in the slowest of possible motions, Gordon's chair
as he sits, rips. Wood splinters, loud as a heavy canvas, torn
one chair side pulls South the other North
a sound of a massive Oak branch ripping from itself shade-bringing Tree

the tearing of HardWood
i joked, offered an explanation but no one cared
Tony, high from his special vapes
a small hand of seconds pass, every bit chills

Aloe Vera on the highest corner shelf lifts
Up out of her Pot, Roots and Green arms all hover
without spilling Dirt, self, or Home
i watch her travel as a Bird inside a house, this house
she lands, he moves

i rush downstairs to find my
Cedar Sage bundle, a match, a White Candle
as i turn up the switch
the lightbulb loudly sizzles and pops all is Dark

ii. how come?

now coming up stairs while Praying
thank you and into the kitchen, Andrew walks in on our scene
holding Oak chair parts he says, *it's your Mother*
in his quiet manner, shaking his head North South

Sage is burning now, softly, with much Smoke Who
billowing thus reveals our joining of worlds
i need not fear my mother anymore

it is your mama, Emma says
on the phone from San Francisco
it's mom, says Mary from sunny SoCal
don't worry, Mother
i am impossible dumb anyway
thank you

my sadness, my Wildness, inability to quite understand
my Ghost relatives chase
hard and fast, they have no doubts
Wolves Run Free

red smoke (not Red Smoke)

climate-change fires
red all red as in a fearful vision of war
the scenes we dreamed and warned of
outside her senior-dweller window

she sat alone in her apartment apocalypse
not a Bird, a Cloud, a Tree, could be seen as
smoke draped, covering massacre's smell and sight
too terrible, saving us from what we know
is happening now

where are you my Holy family? she implores as
she imagined, resigned, her rosary, her body, and the building
would soon be a floating roaring ember
at last, i shall be a flying red Angel
weren't you afraid? i whisper
of what? she retorts

Wild Cougar sits in River
Wild Horses cover with Spring Water
to where shall we run when all is ablaze

Water flows from my hose
i wash ash from Trees, ash made of Bone bits, Feathers
i am hundreds of miles
from the burn

the fires of the World are the fires in my stone-hard chest
stop these fires, clear-cuts, assassinations in
the Woods, open-pit mines
waste, terrible waste
i ask relief from a Star that twinkles on and off
at random things
beep beep, like a broken alarm, yet
still, why stop imploring, i mean
Star may grant me a parking space or a phone call
but when i ask for the fires to be vanquished, for Rain to fall, nothing changes –
or it did, just not soon enough
human-made must be fixed by human hands

the Sky is as full of burned fuel as when Lawetlat'la/Loowit/Louwala-Clough
blew
as i Pine-Forest-camped hundreds of miles away

it is Red at Emma's Home Sanctuary Nest
i can't see the neighbour's house across the street, she said

i say
i awoke last night to the taste of Trees burning
as if chewing burned Salmon turned to Wet Wood

rising (climate)

Sea swarmed, swimming as peaceful as a meditative mist
past shoreline, high-Water mark, through our family house
up high into the neighbours', straight in without any doubt
our Moon has neither hesitation nor shame spreading
cleanly with not much of a sound but our scurry to gather
burying GrandMother's Stone bowl in Sea Sand
Bones of former Stones and Shells

Sea lifts baby toys and spoons, they bob like a clown
pop goes the Weasel
as electric outlets say pop, i am knee-deep
siniq, fizzling, flickering
my pop said, *what is it?* he won't say more than one
phrase witnessing aftermath Hiroshima

where are you, little and big ones, grandpa ma?
i gather up my children and Elders
Ocean pushes, drapes as if a silk organza over brown hips, shoulders, thighs
breakwater, bringing in Sand, Shell-Homed folks, Fish, Sea Stars
all passing by swiftly filling, Mineral Water
never stops nor slows, sloshing into my kitchen hearth and out again
mindful, covering all, following Moon
this is me, Ocean said. *you invited me to be this way*

above are Waves of Clouds, flooding, as others shrivel
i am thigh-deep. who sang here before i
whose cooking presented here before we ate
grandparents and their Sea going, walking Celestial paths
Stars in the Sea, Comets in striped Rocks, Sky full of Galaxies

countries with cars and factories say more pipelines, cars
two hundred Island Nations under Sea, climate refugees

the Serpents at the North and South reply, moving now
no longer held in Place by our adherence to manners
Creator's instructions, and Ice

Sea, being Salt and Minerals and fields of Fish, Mammals, Shell beings, and all
come to meet our FreshWater inland Garden
our Shore, now Seabed no planting, no planting
their meld – where one
becomes less of what it was, and the other more

Land Defenders, Land Defence

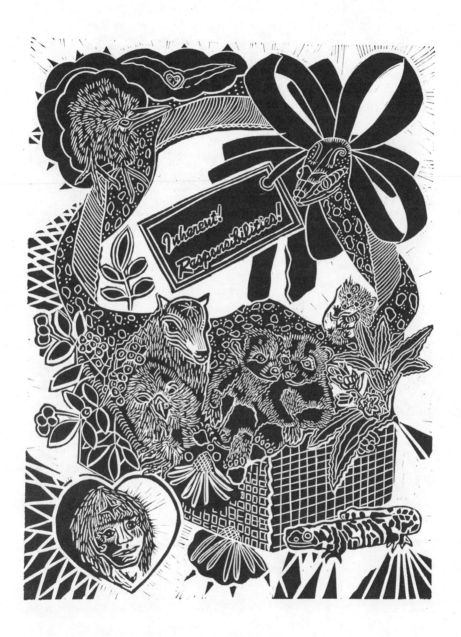

congratulations on your new Inherent Responsibilities!, 2021–2022. Relief print, ink on paper, 18″ × 24″.

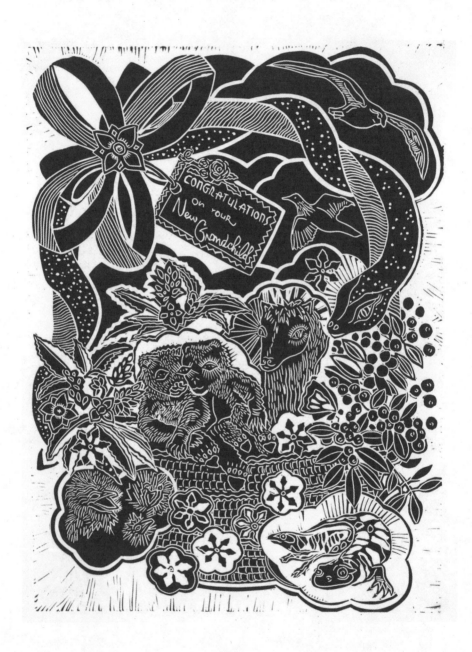

congratulations on your new GrandChilds!, 2021–2022. Relief print, ink on paper, 18″ × 24″.

Rhubarb

bounding towards me as if i were your mama
i thought you were my loyal shepherd
but you were a wire-haired Fox
you – so adorable, but not my baby
i could Love you just the same
maybe ... certainly!
come here

can i leapfrog my intense Love for you – to you?
when adoration surges and rolls
as breakers
i Love you i Love you i Love You

me, primate, shed my hair in Ocean, along Sand
turning my taxonomies from Chimp to Orang to Night flier
as the Sun switches places with the Moon
shining off Earth's precious Rivers, Watersheds, Falls

i heard you thinking by the look on your face
innocently, your muscles defied your will
and shouted in their own manner, your secrets who
blast forward and splash, flicker, Shine

i thought i saw a patch of Golden Mushrooms under a Tree
Dreaming, tightly bound, of those warm airs, long shadows
her Red fist emerging from last Summer's dried skin
Rhubarb wants Spring

reconciliation i – x

genocide's roots
Shoah's truth
parts of a story

Land lungs Trees
Land Blood River Lake
k'alul wits Red Ember Flower
body bodies bound

who or what is behind, beside, below? sirens, ashes, men with saws
incendiary devices begin in someone's hate-filled dream
corporate, government weapons of terror
affect, attitude, and a man on Mars
general, soldier, stockholder
scars, plastic, jabs

hunted, hide play dead, are dead
hunters hunt trophies, human, Plant, Bear
no warning, no consent
made invisible in life, and later again in death

human-made forest fires rage, insane rage, each year greater than the past
the more they take, the angrier they are act behave
invisible stolen sisters, children in school graveyards
child armies, poverty, starvation

today i breathed out Water and a Tree let it Soak

open-Ocean wound
i am a Cloud, forever changing
we grow tired from our circumambulations but i shall never
stop looking, acting, being
Ts'Peten Salt Woman Wind Beings

ii. my high tolerance for the intolerable

under inside Winter-bare River Shrubs
huddled together, Land Otters running as do Wolves, we stay Warm
our infants awoken, our Elderlies hear moulting fallen Leaves turning to Spring

genocide by typewriter, modern treaty
videogame drones, lawless expediencies, endless Indigenous termination schemes

i have no army, i have no gun
i can/will grow any Berry, bunches Flowers
your welcoming, your grave, your choice

fossil-fuel state v. Mother Planet
military v. civilians
fish-farm state v. rural House, Home, Hold
neoliberal state v. Her every Beauty Being

iii. vanquishment trophy hunt

we, biggest, best have our Root breakfast
in the middle of the logging road to regress development of these dark ages

Charter of Rights and Freedoms
he once gave me a weather station to be alerted on my phone
as to the shape and feeling of Clouds

Rights and Title
well-marked trails made of nodding Onions
Clear Streams crocheted around *ƛ́áqa7* Salal to Infinity
no matter how many follow the path
Pika, every other being who eat all they may hold
no one may be lost, not a Soul remains hungry

path to Justice, path to Healing
are now tar rivers, black-mould trails

iv. state-sponsored violences

computer, rare-earth magnet, stock market, boreal Forest
arsenic, giant mine, gmo
telegraph, rail line, herbi pesti omni cide
abandoned mansions, former cities less than
fifty years old

this short-lived economy created no Tree ring
made no Sandstone layer
human geology tar sands wounds

v. who is your Mother?

genocidal/omnicidal actors, mass killers and their shareholders
to the person who is the corporation –
Who is your Mother?
where is your resting place, your haunting locale
for your dead, dying, SuperNaturals, Spirits

vi. harm

those which are made, those which are given
we who receive, those we deflect
we who survive, we who are reminded
geology is too slow to reconcile this era of doom

how to speak from the grave? listen listen
Old Growth fill rusted trailer trucks, Ocean-crossing ships
i ate spinach with chopsticks and wondered, is this You, BeLoved? oh, why
must i eat

Bear hunts, trophy hunts, clearing Land for street lights
pollution-darkened towns
development they call actions that impose hunger, poverty
war refugees, environmental refugees

vii. power

who did you kill to lay your pipe (not life) line?
how did you live, with those hands

soldiers burned Gardens of Plant Parents, Ceremonial Sisters
hacked and shot Mice, Chickens, Deer, our families
so many dead, We are buried in long trenches, in heaps

> Mother, where is our village?
> daughter, soldiers burned it, long ago

viii. making place

my Forest Home is under ruin, pipeline man camp
where is it, where are you, with Whom i may rest

i work in a brutalist building, live in a city hostile to Life
spikes on rooftops deter Pigeons, Eagles
We cannot sit, rest on our Migrations

spines on benches, flat spaces, obstruct houseless folks
so they may not lay me down to Sleep
hibernating Medicine Bears, hunted as Babes suckle in Bear-mama arms

ix. truth

Every Being is moving all the time, shaking, scratching
a Rock under precious Soil looks up, reaches towards Stars

x. victim v. victor

survivors, overWintered Seed, eventual revelation
Ghosts of Responsibility/Rights, our relentless
constant Companion
whispers shouts inside your skull, sails arteries, enters in outbreath

when? now *who?* me

tell your story
paint your Dreams
poem your sadness

pick up

pick up your Cross, Four crossed logs, Four Sacred directions
Whirling Power of Creation always re-Creating re-Making
new-Branched Tree of Life, many-Petalled sweet Berries, Pollen

pick up your painted sign, walking stick, paddle
your glad rags, newly Woven Dog hair Cotton Wool Grass cloaks
shoes if you have them, our hard-soled feet

we will never stop looking for you
we will never stop defending you
arresting us will not stop us fighting for our Land

my Weaving Axe is near my bed and in my car
no one's victim! at the ready in case i find a Storm-downed Tree, splintered
Beauty
and ask for Bark, promise to Live again as a basket
or those cutting Forest, find me first
don't cry, Fight!

my/our/your inability to obey lawless injunctions
genocidal instructions, ensures i/we/they may
have a chance, fulfill Creator's goal, to Live, Survive
Thrive on/with this, Our One True magnificent Mother

heirloom Sewing hammers Embroider all past
present, gifts, Spirit, tomorrow
stitch it all back together, a stitch at a time
Peace would be made this way a new day, will be now now now
come on With it

scissors, nearly frozen from lack of use
re-open to their Work, cut cloth into clothing
open, Open, this, Land Defence

on leaving (humans disappoint)

honey, leave first, but only after you turn your barren heart Lush
i can't bear to see you chop, slash, shoot with bravado
massacre of the Innocents

don't fly off, joyful, as if to warmer climes, after you've left
it so cold, forlorn, empty
how are your heart hands mind unsullied by your war, leaving us
truly naked, alone, moonscaped, tar sanded
how am i to Love you, enemy of all i hold most Sacred, Creator's Heart

after you, how may i sing Songs to the Swan, make dances to
Gulls who fly thick
as Clouds, when after you, not even Bones remain
dig shore sand yet no Urchin shell says *hello*
ShoreBirds stare, waiting for the return of a Just Earth

after you, who may live? let us hibernate ten
thousand years in underground bunkers, let us dig our grave, cover
ourselves with a door until your gloom passes
and forests become Forests, once again
we must make a Song Prayer to outlast your ruin, we have already Begun to Sing

your turned back as you walk away, satisfied
the end of your workday. now on to your other lives, other manners
whatever makes you – my Blood cannot understand
you better smarter? and we, proud to be
thousand-year-old Yellow Cedars, Snowy Owl Nests, Bear Dens, Lichen licorice
end ache hard atop logging trucks
i don't want to survive the world you destroy, no one will, may, can

darling Forest, don't you wish to stay? can't we be fallen down
lost together, blind in Love? Love transcends all, as we imagine our
Spirits bolt as Antelope across Rock slides who roll downhill to
River pebble Salmon birthing Home
Forever, Eternal, Now

slash, burn, profiteers, loyal to violence, hope killers
epidemic suicide is a colonial imposition

Keep it all together. it starts with a Dream, a simple thought, a Seed given
little chance to start, Native Flowers, Oaks baby-burst through
highway cracks, Dandelion, Plantain split cement, shouting *Live!*

human dear, you are not a Runner, not a Flier, not the
one who will Monkey Wrench Love preventing Hate
the last open-pit slash burn, goodbye

i polish my tools
Bees in *tšúṁxal* (Orange honeysuckle) Wisteria
BeLoveds of great Work and Joy, my neighbour calls
both weeds and pests

i saw you (personals column)

you are so painfully handsome
everyone stares

you were wearing a Bark suit, the type of which
Bears are made. i ate Bark, one Winter awaiting first
Berry Shoots. you smelled like Spring, like Rain and Hope
full Rivers, full bellies
i am in Love with you
so hard

ii. woman with a mirror

naked beauty, Goddess in Ada'itsx
she held up a large mirror, and when he
rcmp saw his own reflection, he snarled
at himself

she covered in Mother Earth Dirt
awaiting the handcuffs, with the smile
of a Saint, those persecuted for Loving SuperNaturals

i wish i were there, with you and Yours, but
i am nothing and no one
the sight of an engine makes me leap as do
Gazelles and those them us we easily spooked by bad smells

i wish we could meet and i would
fashion your hair into two lovely braids with Red
cotton ribbon

iii. camp cook

your long-fingered hands soothe Rosemary, Chamomile, Sage into willing
Bundles, each a Family of diversities, comforted
their own and their compatriots
Aroma, Force, Usefulness

every pan and pot clean and ready
or filled with Food for the front lines

your face is smooth, clean, and clear
as a jar of Water, with the Sun reflecting from behind

iv. baby

serene calm, a state of being pursued by Cloud-dwelling monks
emanates Freely Easily from your mama and your perfect Sky-eyed kin

our destiny comes in salty Tides, iridescent Fish
fur-Shine Mammals, Stars, and every growing Being

Openly we greet, meet with sweeping rushing Waves
our tireless repetitive embraces every Day every Night

our today we make is tomorrow's beautiful
Peace

v. heavy sigh

i saw you
i lost you

every Day we met one another, and every Day we
breathed hello, in awe, in Love, Majesty

you, your Emerald beingness, you would wave at me as if i
the only one in this vast panoply of Souls

now, in place of your cool dark abode
a gravel lot. i look for you everywhere, even for your relatives
where on Earth could you have gone?
i dare not see

i plant a Seed from a Cone
knowing i will wait lifetimes for your return
my BeLoved

Oh, canada (Heartsick on the occasion of the latest armed invasion against Indigenous Peoples, Places, Laws)

a small bunch of Flowers
gorgeous as a Spotted Towhee, rests, awaits
on a tray atop other bunches made of bunches
Roses, Ferns, Baby's Breath
i eye them as if Cake

may i have one? they appear to be orphaned, all
pretty, perfect, made, blossomed this way
no. these are for the important folks – him, her, the other
oh, yes. of course. familiar, heavy Heart. sorry
i understand. i do.

Director sees me, reads my name badge, sneers and walks away
hee hee. *hello Mother, are you here? she fought for every little bit*
the room is flashing from suited smiles, hip and conservative stylish
jeers, all shake hands congratulating self, meanwhile
black mould grows, petroleum fills teapots, flame retardants in Arctic
Mothers' milk, swift sorry lost
diesel fills Camas beds and kindergarten basements
fumes, want, made from greed

i used to be and am expected to cower, feel shame by those shameless
regime collaborators, their orders of, from canada
unable to, repulsed by, mute in their anger towards Birds

ii. every day, every way

no Ants invited to share Food here
our same stack of tidy Rights, Responsibilities, and bunches Flowers
all still awaiting promised partners, left
behind unwanted unclaimed invisible extinct
sitting on a railway Blockade

high-flying Condors are both alive and extinct
our home, the jailhouse, our Home, this Land. our Home. Our Home
Responsibilities (Rights) Sacrifice (Rights) for You, Earth, Water, Land
when empire cuts off my arm, i pin a Wild Rose upon its stump
who Blossoms in this World and the Next

oh hello! we recognize one another
Love to you, Beaked Feathered sprays – your Promise, Splendour
your abode Tundras, Bogs, Boreal Forest
Shore Home Miracle Nests
clean Water, clean Food, clean Air (Clean)

you, a smiley Gift from a secret someone
unaware how much joy this has made, given, gotten
in Spring, where canada's snipers target Herons' heads
Wet'suwet'en, Mi'kmaq, those at Ts'Peten

you, Lowbush Cranberry
Trees as small as a Swallow's foot are my funeral Wreath
Muskeg Moss, Melting clump woven inside my hair as we
both are going, gone, went
perhaps you are my frozen Ashes –
Sea Foam, North Pacific Gale

train crossing, highway, bridge
roadblock, Righteousness, Return

Love loneliness

Chili, Cocoa, Sugar made into skulls
every Easter and harvest Moon, we filled them with
small animals, roses, lilies made of frosting
Red Ants, Cave Crystals, Marigold Fields
someone throws Rocks on my roof Who tumble

my house, almost empty
seven billion people on our BeLoved Planet
no one speaks, no one listens
offers, enfolds, both Our hands
grandfather, a Wood carver, grandmother
raised orphans

ii. independent

we slip as leaves slide, our Dew-damp Deer trails
Owls sweep between impossibly tight-twigged Hemlock stands

i would walk with you, only if giant Spirit Elk would still appear
only if rattling Altar Serpents would yet stand,
only if Blue Spirit
Lights continue to fly and swarm
but i have no proof of you
and i need Them

Wind's sweep, Beach Sprays
an uphill, rough Stone path
time to sit
chained to a concrete tube
buried in ancient Soil

ancient Trees, Medicines, the Root of every Being
true Love
my BeLoveds massacred by men and saws
my Loves are
under fire under siege

Land is a Halo

how do i get here? to you, to You, and to yours
i am on a boat who carries cars in her belly steel space
back and forth, to and fro, as
we change our mind, daily, as to where
is Home

Mist from Salty Mama surrounds her
primates lean against her railings to be
in the Halo Wet. some hide inside, but watch
shadow, glare, Waves

Whale family, up and down Ocean's heavy embrace
ignore us, rightly
as their dark bodies come to our shared Breathing Air
their lungs, Salt Water, Sun, arcs
about them. who among us carries
Divinity?

our boat docks. bits of Ice who were once Rain
once Ocean, suspend at the ends of atmosphere
Crystals cast a circle Rainbow
around our celestial ruler. Berries, Roots, and the
innocent, understand

i have come to visit Ada'itsx (Fairy Creek), a place of
a better way is here

Land is a Halo ii

Land, Water, Air, every Being
Land an ephemeral, regenerating Halo
Her radiance surrounds envelopes every
Hallowed Beings, community of Souls with no beginning yet
tragic ends

Spirals made of Mist, Rainbow, Sun, Seeds
Moving, Sovereign, Energy
Re-Make every day, every moment
you fill the circles with all your luminous Dreams

her bright-Making Shine
embraces, envelopes forever growing
Rights, Relationships, Justice
we inherent, tangible, true and real as
Salt, Salt
Woman lives yet

Land is quiet, blackened spaces
vaults full of eye Shine, massive Crystals, vases of ageless
Winter's Souls in the form of Rosehips, Marigold seeds, Rhizomes
Embroidered Flowers, Brocaded Moths, Fireflies
Deer our Air is our Air

Land is a Home, Place, Shrine
we belong to, with, intertwined as blades of Grass inside centuries
of Sod. Prairie burned, Soil blown off, stone footing, skitter

act for, with, in
Sanctuary for the indifferent, Sanctuary for those who help Her live
She Gives to all
Beasts, Beauties, Benevolents, maniacs, all are given to
she is borrowed, broken, Beholden

Garden Cherry Tree (Land Protector)

 time to Plant, Johnny said, spending all day pruning Cherry Trees
Who have Life to give, surrender
pie, tart, sour, sweet, smack lips

but the Bears? i ask, the ones who live behind your house
he makes a pile of cut limbs
 run to the Mountain, Tšzil
 run to the Mountain, Tšzil

burn pile, dry Grasses
isn't this how John's house was set ablaze?
 i have to clean, he replies
i went too far, it is not for me to say

after the Ice melted, aeons ago
from far South came a man (Man?) with a present –
Potatoes, Who Grew and Fed, still Grow and Feed
when Johnny returns from the Nation office or
from Walking the Land, Defender
little Birds run out of their tiny houses
 hello papa! they chirp

today Johnny's shovel opens Soil. up comes a Stone who is not a stone
rough skinned, oval, a very Old One
 hello, have you been here all this time? he asks
things we think/talk of while Gardening
 did the Land look this way when you had first been buried?
he shows our Stone who is not a stone, lays Stone down at the view

Johnny sweats, makes rows. Stone lies on her belly, watching
 i remember your GrandFather, she says. *and his*
another row, another handful of Seeds, another Stone, face up
 you do remember me? he asks this Stone with a face

before our Season is done, Others reveal themselves
appear in our Garden Haven named Feed the Front Lines Field
She has a Moss coat, He has a Lichen-covered face
some have Water marks from reliable Floods

i don't know, i don't like asking questions
rebirthing of the Ancients ageless transcendent
Johnny says,

 these are a big SomeOne. a Being our world knows not
if it were someone else with the hoe and rake, i would worry
but it's Johnny, and he knows how, what, why, Whom

another, five, seven, nine
Lightning Flashes, not a Cloud to be seen
he has set these Ancients in a row where Wolverine's Orca Beans will Grow
making thousands more, Orca Beans

Beans, Bowls have Faces almost covered by eyes
much as Caves speckle high Boulder Mountain reaches
hidden by Trees, Brush, Sparkle

mouths like a Frog's, Who calls in Ceremony
wide lips, open mouth, Bug tongue
(be careful! don't talk all loose)
 they are those
 the most powerful of them all
it's not my business. i look away
i want to know but it's not for me to know

Thunder out through hands, head, to Sky
and it all begins again
half-covered in a Soil blanket
 who are you?
you shiver up from below Glacial Soil

what now?

Working Dogs, Land Defenders' Protectors
wag as they eat
celebrating *now now now*, victory in being alive another day

good things – Miracles in sweetness and in bitter Roots or
muddy Water (Spotted Lake, Flora Banks)
breakfast, snacks (Grizzly Mountain, Cache Creek)
lunch, snacks (Meares Island, Katzie Midden)
dinner, snacks (Green Valley, and all them any rest)
may you have all you may Want, Need

eye-to-eye ties that bind
hugs, Slush, Mud
live bound to/with/in Place Homes Sacred Homes Holy Wild
hello Yaqalatqa7, Hubie, Kanahus, Freda, Sleydo', Every One

Power Streams from Whom to Love and be Loved
evening cook Fire, daylight circling Bugs
upon whom to contemplate, a Just world
drooling lips with which to snap, bites in
Clean Water

hearts beat hard and fast as Ceremonial Drums far inside the Trees
running Water, run fast, Free, crashing Brush
chasing shadows who are
uniformed weaponized men

tomorrow reminders will come
via headaches, droopy drops, howls, limps
i will ask why Life is this way for Indigenous
you will say
i shall do it all again
because i am Fierce
running Love

today's happiness – so sweet, it's almost hot
greasy, heavy, glorious
we pet, pat
now is now. a time of the rush for every last Sacred Being
i am doing it all again for my BeLoveds

this Wild Good Dog park is a last Stand of Relatives, Relations
Sacred Old Growth, Sacred Wild Salmon, all Who matter, Here

Now is Now

Forest Defenders' Defender
remote dweller Companions, those at risk vigilant alarm

do anything for you
do everything for yours
your Food theirs
your Fight theirs

forced disappearance

i tend my Field on this grey day, the time when where
Winter and Spring mate, one destined to say goodbye
the other hello
these Cucumbers are doomed to freeze

a helicopter, suspended, hurts he who
holds, and the spaces in my body
it slices its way North, South, East, West
unholy pounding tour to all far Four corners

a Whale in our Indigo Sea, turns as i do to
look up from Compost, Seeds, blameless Hope

are my Friends under arrest? are you
coming to kill us, our kind, our Land?
will someone please turn you off?
oh won't you please shut up?
would it kill you to stop killing us?
stop. all you need to do is stop

now, where to, you
high as a kite, you chop *Ixtepeque*'s (Obsidian)
face into shrapnel
Feathered Serpents, hard-Worker Twins who hold Ice poles
together, split
all for you, doomed, falling, empire

village of my Mother, caught unaware
our children Plants, our baby's baby, every one
burns. proud army shoots every moving
breathing, blinking Being, murder assembly of Sacred Souls
no Deer, no Spotted Cat, no Rat, not a Hummingbird
fluttering hearts or woven ones, safe, able, allowed

your hands, your hearts
helicopter, who made you? soldiers, who trained you?
why are my families extinct?
why have i no Home where i may return
no plaza, no playa, nowhere to join old dirt-coloured bones
please, stop asking me
where i am from

ii. go away

we counted hundreds of thousands of Starry Night Visions during
day and into our Sleep, Asteroids aflame, daylight Shadows of
Old SuperNaturals with no predictable
shape, Spirit Deer, Dragonfly Fields full of Rabbits

if i count to twenty in practice of our giant celestial Wheel
will you, when shall you, disappear

are you now landing on my father's roof?
are those sounds your soldiers' feet, our roofs crunching
dried Mud ceiling powder down, a fallen Nest

this extended families, these, i mean
your hand is an impending flood, washed-out Food Garden
Corn, Greens, compatriots wedded to our
big empty bellies
we exist in Dreams, Stars, luminous Oceans

i we remember our Midnight Ancestor, visiting
She slid her once-human feet across the hard-packed
Earth floor, awakening
loudly, but calmly, slid her hard Clay cup across our Wooden table
pouring our terracotta pitcher
full from Springs

A7xa7 (Sacred Spiritual Intelligence)

*A7xa7 is an Ucwalmícwts word for Sacred Spiritual Intelligence
shared with me by Yaqalatqa7 (Johnny Jones) with Love and permission i share
with you*

Power, Understanding
ability to listen, hear, comprehend
A7xa7 remembers and calls back Sacred Lives and Beings
lost, before their natural end, taken, stolen, betrayed

lost to modernity, greed, call it what it is
there shouldn't be a choice between environmental ruin and starvation

A7xa7 many-Beinged Forests (clear-cut forests)
A7xa7 Land, Sacred Land (open-pit mines, tar sands, other massive ruin,
poverty makers)
A7xa7 Wild Sacred Salmon, Bears, Wolves, Caribou, Wolverine, Ermine, all
others, too
A7xa7 Women (MMIWG)
A7xa7 Men (rcmp starlight tours, jailhouse)
A7xa7 children community family (Indian residential schools, missionization)
A7xa7 Water (dams, rivers alight, fracked aquifers)
A7xa7 remember, re-call, re-Sanctify all taken
broken, vanquished, dispossessed, made extinct
A7xa7 we are re-building, putting back together all that was/is broken apart

remember, respect, and call those Sacred Lives and Beings
honour all those who defend Sacred Land, Water is Life, Mother Earth

Helpers, BeLoveds of the Land are Active, Power Beings
special ability, special sight, deep hard feelings serve the Work
maybe distant, maybe near, maybe in the space behind the heart
giving knowledge, support, strength
Love and Thanks to Power Beings, Help, Kindness, Empathy

SuperNatural Beings provide and make real
Animals of all names are the First Teachers
Love and Thanks to our Ancestors, histories, memories, BeLoved Ones

burned to the ground

you stole my Water
my Water is missing
Saints and Flowers live inside her
woven, embroidered armour

i am Weeping in my Sleep
she runs past – Madonna and child Polar Bear under melting Stars
 Indigo Mountain Goat, she, her young, themselves only Ghosts
 Beavers awakening from their Sleep of Angels
 in a dewatered lake

Ghost-Dance Swallows, many-coloured Lightnings
warn of a frightful storm by darting, swooping, to let us know
the storm is now here
without Rain

morning-Star path, Earth-Mother Life
Volcano cloak is a long-Needle Pine Forest
Lava Mountain spouts Sunspots
a Breeze from her Dreams joins chirps of Birds, ruffle of Wings
their Faith in
a Just world cools his Fire head

fleeing, guarding, watching
break last year's Pinecones who
break those from before
releasing Seeds

Land Defender woman, thirsty, wounded
turned away from those afraid of her enemies
welcomed in by those not afraid to die
given Water, Soup, time to Sleep

ii.

you have stolen my Water
with your first strikes, your garbage, your dumping and pumping
she said no, but you kept on

in another universe, where you have no hands
her unreachable Home for Name, Ceremony, Planting

in Homesick loss Heartbreak they cross
sneaking into their Land where those who ordered
burned fields, scorched earth, genocide
thrive. those who caused all of this
running to the promises of a constant abuser
away from his guns, poverty, impunity
calendars counts made of sorrows, perfumed Blossoms, Spirits

Water bottles, precious Water, Desert scorch
drinking Water left by citizen Saints
volunteer militia spend time emptying old milk containers
dump precious Water left for thirsty shoeless
Martyrs to empire
onto desert Sands, capital

Maya Elders, old man's wife, grandbaby in a net
given Rest, Water, a cot among Hens, Tarantulas
too killed for being too close
to our BeLoved Land

my heart, broken (BeLoved Mother Earth)

turn on the light, don't leave me!
leave the door open, i'm afraid!

monster in the closet, leviathan under the bed
ode to the days when phantoms wore hollywood costumes
not police uniforms, judges' cloaks, shareholder deposit slips

shadow man lurks, his black hole
expunged by Camp Blaze, Ceremonial Fire, candle Flame, Prayers
in any corner of every community. we are under attack

massive Trees, mythic grey-boned spectres, an old lithograph
brittle paper, smelly book, our only reminder save Songs, Legends

Aquifers once clear Oceans UnderGround
now empty, awaiting St. Theresa and her Red Wild Roses
if i mattered to you, you'd lie with me
under my handMade quilts

i have to run, in my chest there is a pounding of
thousands of Flying Runners, as they did, do
you, Bison, who last week appeared en masse
amid mass arrests, police violence, breaking of
the Lodge Womb – how you enchanted, how you made Clean

to their pointed guns, water cannons, we said, *i will never die*
drenching of our bodies in freezing Winter
we will never die

ii.

Hematite's Earth maps lead eternity's global constant Pilgrimage of
Whales, Fish, Birds, Moon, Planets, Stars
even Sand, on the run

flocks of rare Snow Geese winged in Air for days, land
the only Water, last year's childhood Lake has been re-Made
an arsenic pool

eternal return, Buddha's endless cycles
cheated, even of this, my Grizzly, spotted Toad
climate disruptions wealth
is our walled-in cell

haláẇ Golden Eagle alighted upon my bed, still, in calm repose
thousands of Caribou
how they open, soften my awaiting Grave

Grass Fruit Field, Prairie Dog Home
oh my childhood demons, you never
wanted every Living Being
oh my childhood Ghosts, you never
dispossessed, vanquished
those who made you never thought to
blow it all up

cutting of the Elders (Trees)

we drove through Quinault, either side of the roadway
clear-cuts, piles of slash, left behind
we slept in a cabin with a heater empty of propane

in our Earth flannel Moss Winter
Home snug Bear fur Bear Den Bear Babies
Hemlock shadowed Black River Fish Pool
BlueBerry Bees Sleep buried beneath Seeds Rhizomes

Fall Chill rises from below Roots into Blood White Bones
Sun reminds us
Give it all away

Peach Trees need Winter's deep to bear alongside Summer's bright
loneliness
if, when, we eat
all is well

from below the stairs, empty space, basement
internal organs rattle. from the Cold hard Ground
boom comes from both out back and out front of
this old house, a black thud, Land's heavy call and
response, the collapse of Ground Hog's Homes
Earth's Requiem for the fallen Elder *tšútšxȉaoż* Yew
someone on television said there used to be Giants
wandering the Land. this we know, we witness

chainsaws have been buzzing shrill, angry, ravenous he
hits just for the joy of cutting with metal upon
Flesh. while sitting in a car, he said
one day i am going to beat
you up just for the hell of it
today, a judge in superior court

you are a bomb

as you walk through your Life attached to mine
all others, and the Stars as they eternally Spin, spiral, drop in, pop out
many Suns, Sparklers, Holes, make Webs via their chosen
paths, prints, maps. we may count them, watch them, Pray
cajole, curse
no matter. Theirs is Divine, attached to Tides, Snows

the path you made, the hands you wash
did they make a Garden, a Nursery, a Dream, a Wish
did they contribute to Sacred safety and fearlessness
of inaccessible locales?
some HoneyBees hibernate in Garden Dirt
restful Ponds offer Nutrition
Every Being Gives

i live alongside bombs as they fell Forests and all who live
collapse Salmon baby's bassinets, filling infant cribs with shrapnel
bombs made tar sands, where no one may or can/should or could ever live
not for one minute, not for one week, not even a place
for of dreams

you are a bomb, leaving ruin
equal to war
you make war zones
refugees, species extinct
loggers say, *our bomb feeds our families*
as we all
starve

tinder

alight
above beyond
spaceship
cigarette

a Land where all seems dust (after the cold war)

legend says to be afraid of this frightening
polluted left bank, full of the same plodding Mud who
stopped world-war soldiers

conquest thwarted, Mud remains, refusing admittance to anyone but
Seeds, Planter-Beings, Birds, Clouds, Dreams of Peace
i slip upon, laugh. tomorrow, we say

don't go there, he warned, i recall admonitions as
now already here, i drink the sweetest cream coffee
at a gingham-tabled shop, blue as a Spring day
windows cleaned this morning with rag and powder
grey-covered by noon, trucks moving nearly atop

history's steel rail, miles of emptying into grey lands' end
irons, downStream from empire, war
looting of playgrounds, Fish nurseries, Gardens
he said *quit*, but i don't believe in
gritty mouthfuls of hopelessness. spit
not a Stone, but something
broken Stones make. i believe
in Clay pots tempered with GrandMother's broken
Clay pots

morning Dew set hard in Gravel's spaces
underfoot break, call out somewhat like stomped-upon
dry Snow. rosy-cheeked, Souls constant embers,
Mothers hug themselves, chit-chat, their coats thinned by many
Summers being packed
away under beds

no matter what matters
blinky children on rusty swings, creak. laugh
Earth's many Powers all around now forever
today Earth thinks to be and make Sparkling Granite, plotting Her
release from
underneath. we rattle, speak our dialects, work out what
we mean or might mean, and laugh about what –
we are not certain. it feels like family, we
strangers all from the middle of Earth and Her volcanic dreams

i Feed all of the Animals, GrandMother tells. her mission
her Work, her important hands

her yard is full of relentless spots of cold-war era Grasses
who never let go away who never flee
these boast their Green all along her concrete apartment
she can see who you are, as if peering through
you, a sheet of
glittering Mica
she wears three scarves atop, waves to
passersby. next door each door old friends sit
tightly on stoops, as do Mourning Doves. walk closely together
as do community Dogs. we brace for Cold, watch for signs from
indeterminate Clouds
Love and Kindness

the lady who feeds all strays and hungry folks said

if i had teeth, i would look younger
if i had teeth, i would eat supper
if i had teeth, i would bite

Make Real Our Inherent Sacred Righteous Rights

terrorism's terrorists wear uniforms supplied by canada to
detonate conflagrate military army against
historic name, Indian, Indio you know us the ones killed
to bring us to zero

guns landmines fists germs chainsaws invasions
hey you – learn, tell teach of those who or what made us into
heart-sharped seed-filled shards
we grind ourselves together, mix, Make new

institutions, prisons, tortured fish swim tight circles in swamped pens, bruising
fluttered gills pant, eye-burst panic
Food, Food Relatives, our Homes, Fix. Return our Original Instructions
every Sovereign has Laws, Manners, Obligations

ii. heroine

heeeeere's johhhhnnnnnny, shining axe-flaying fiend
movie audiences scream, splintering with all his
might, Mother Sleydo's only door
live forever, Wet'suwet'en, Lílwat, Maya, Black Bear
Mothers and Childrens

uniform set my Home alight, Smoke wailed in Black vestments
all round. Fire, handcuffed trespasser (me i mean), i aSleep in my nest
woven from grandparents' bones
you will find mine someday, buried or scattered and i will still
tell all, of more than Life-long Love

Tsemhuqʷ Kanahus Sleydo' and the many billions
every obligated aligned within Love
i Hold you (for what it's worth) i tell everyone – hard

Land Defenders maimed, jailed, hospitalized, dead
Land Defenders targeted, trauma-shortened lives

iii. Stones remember hands and recall our Homes

front-line Mothers, women with wombed babes
hunted down, axed from their Winter dwellings
Mama Bears Sleeping with their infants in Winter Homes

what to do with you when all
we are is recalled by Rocks

iv. track, target, murder

Kanahus said, *Indigenous women are over-policed, under-protected*
rcmp kidnap our children, Indian genocidal schools
rcmp broke my wrist

armed men burned our Mother's village
everytime i hear a helicopter i look up expecting death

injunctions are a licence to maim, hunt, kill we
gunners in helicopters murder Wolf families, Wild Horses

we Invincible invisibles, Nation-wide reconciliations
global movements towards Peace

v. big car

uniforms behind blacked-out windows, they travel at least in pairs
we three cars on this remote long road
anything can does happen, Highway of Tears, Starlight Tours, MMIWG
a parade of military tanks held off – Ts'Peten, Tiananmen

aching joints from Sleep in Autumn Rain
will i die today? will my body never be found? never mind
i'll do it all again

a Wild grey Mare runs open Land
her long hair flying, cleaning, her Peace, my Peace
let's all be Wild as we are and were

vi. Berry picking

Berry picking, where? red-listed destruction of a *s7ístken* Home Hold
for pipeline, my sister's Home is under Ocean Waves
a rare Fruit Plant Parent that is more and more hard to find

Kanahus instructs, *Indigenous women forced to go farther and farther away to eat*
our Indigenous Foods, cure with our Medicines
whenever we go out we are at risk from
man camps, police, acts of war

whom do you call to ensure your safety while under fire
when those with the gun are those at the end of the phone

rcmp comes, steal our Food right out of the freezer, pull
Fish off of our Smoke racks, goes into hospital rooms, taking
newborns from Mothers

we have no safeway there is no safe way

vii. broken arms, broken wrists

downtown is warmer than home with its lack of Trees, blacktop-soaking
Sun Colder as a bus blows by shrieking with Seagulls
Wind between buildings blows hair across my face, obstructions

flyers photos on street poles warn of a bad-date man, be aware do not
date him, this father, husband, murderer
there he is, prowling, free to kill

there's my rapist, she screams, he turns his back. mother points
shouts across the street, *you killed my daughter*, he sulks away. everyone
knows bad dates, bad cops, bad man in man camp, human remains

·how to live in Peace, after genocide, as it continues
what words shall we make for this

direct action crew

Land Defence is Survival
Land Defence is our Inherent Right to Life
to meet Responsibilities to all Life lives possibilities

old testament *an eye for an eye*
a Home a house

ii. Sovereignty is Fierce Love

Fish, self-determined
no one may command, give, go, stay away, come back
feed us. make us grow, make us Real. Make this Earth
Real, Perfect, Shameless
They decide
Right Action, Right Thought, Right Livelihood
all we have in return is Love and Thanks
i bow to you in Humility

Fish eyes in Raven bellies, stew Meat, means
from Salt to Fresh to Live again as Wolves, Bears, Tree Roots
Soil, Sprouts, perfectly useful teeth

Salmon, having made new Salmon, turn to the Skies, our shared
eternal next Home in the latest *Tun* Turn
Breath leaves up becoming shooting Stars, Pine-Mushroom Spores

colourful Decay, Slippery Guts, Flies, and Bees
their death smell is a breakfast bell to Fox
Mammal Insect Bird Feast, Gathering

delights dead Fish eyes contemplate Life's purpose, having
reached Nirvana
Hero's journey, fulfilled

Sutikálh Hubie

Majesty soaring Sky Bittern, Made perfect, done perfectly
DrumBeatHeart Song Protector Helper

Earth Whirls, Whirling Logs, this Power of steadfast
Seasons, confident reoccurring Creation
Heals all, gives Breath to all, every breathing Beauties of all Breaths
day happening now as true for thousands

Water's constant transformations from *súsuzil* Glaciers to panting sweat
Frogs are first to sense *Winter Spirit's* reappearance
strong hold, Hold Strong
strong Earth, hold Home

how do i Love You? *-alh Home of Sutik Winter*
Spirit, Spirits – Souls of All who are ever Forever
what may i give? You have all Who you need
i bring a can of Beans, a box of Apples
never bring your own Dogs, these are working Dogs
Working

ii. solitude from other humans

surrender, say goodbye to all you
leave behind, as a Salmon must to Ocean Home
in Service, in Fulfillment – our Sacred Responsibilities are our Rights
as Sweat Stones born of time travel from Fire to Water help, helper, helping

Hubie solo, apart from humans, with his Guardians at the Gate
What is Whom, Witness, this World is one needing protection from
skiers, resort owners, helicopters, thieves
angry men, gas engine, come here, so far out of the way
beating Hubie and his Dogs
to set fire to those Homes

iii. *Place of Winter Spirits*

Home of Winter Spirits call out
no one else can be heard
Beings of the *Home HouseHold of Winter Spirits*
Hold horribly Holy hard all that was and shall
ever be

all profess ancient earned Names from before the Glaciers' time
passed, will pass again, and all Winters in between
Tomorrow's Grizzly will live thrive recall this dark age

iv. reliance Rice bowl

bad men with baseball bats
want the Place of Winter Spirit ski lodge mountain-bike trophy
state-supported hunt, attack
their sports are broken bones, excess, engines
destroyed House, stolen and burned Food, tools, Dogs

when the railroad came, it all went
mountain-bike trails into Grizzly dens, Graveyard Gardens
kayaks intrude, dismantle, souvenir shop at Sea-Cliff burial grounds
there are Homes of Many who need Solitude, Stay Out

Place of Winter Spirits

olympic skier granted tools to invade, ruin
ski resort helipad parking lots condos and cocaine
Never! we Vow

their recreation fun time vanquishes, kills our most Holy Homes
original Dwellers, Healers, Makers, World-Turners

there is no reason, there are no possibilities
without *Home, Winter, Spirit*

Yaqalatqa7

he Trained Old Way
circumambulating Lakes, Mountains, Glaciers
swimming beneath Ice-covered flowing Waters

he is called, *can you find my missing one? she went hiking, somewhere?*
people from another country, Mushroom pickers, who ate the wrong type
found in their tent, as if asleep

he Walks the Land a Land who says *I Love you* every day every season
he finds mountain-bike destruction atop Grave Homes, Altars, Springs
Holy Places invaded by recreationists
building roadblocks and being
a Roadblock Warrior

his sweat mingles with countless many Deer Bear Ermine
trails from interior to Ocean shores
Traditional Territory needs Guardians, Walkers, Blockers

S greets him as do his uncles, their feet and faces Black with Frost's hungry
Bite, having Walked many days over Glaciers flying Ice storms
no Food, no boots, no gloves but a thin shirt
saved by ████████, brought back to the family Hearth
fingers, toes, bits of a face traded
towards another purpose, another Day

all live on Land, live with Land, live for Land

ii. what it takes

his Fist, full of Earth, Sƛ́áƛimc House Home
Held high as a bulldozer advanced roll over smash
machine, man, showdown
Sovereigntists are not terrorists

Tsemhuqʷ

Watchman, who is?
he travels the Territory his entire Life, Spoken to
given Songs, Sight, Land Water Spirits, Beings Whom
we can't describe here, it would be impossible without his eyes

he is the Nation's first line of Defence, the one upon whom to call
he Walks the Land, Bathes outdoors, memorizes where Tall Ones stand and
Grizzly Bears make babies, eat Fish, and share Medicines
he finds trespassers, their taking, their riding over Graves, for example
he is Defence, Witness, Strong man

Tsemhuqʷ sang amazing Beauty Prayers Songs made with
whose Helpers made
for/with/in/alongside community, for gatherings great and small
some special humans are given Prayers Songs to bind us closer to all that is
Powers, Beauty, Survival

where is the hague? Watchmen know, they walk, Witness, there
International Court of Justice, to where shall we turn when canada is the
offender

Mark My Shortened Life Live Loves Laments

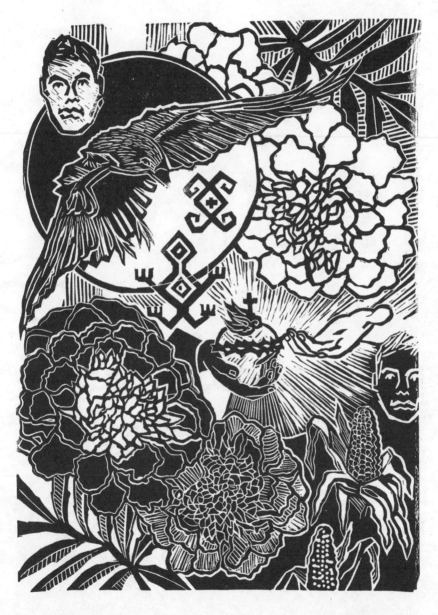

ya me canse (I'm tired) for Mauricio Ortega Valerio, 2015. Relief print, ink on paper, 18″ × 24″.

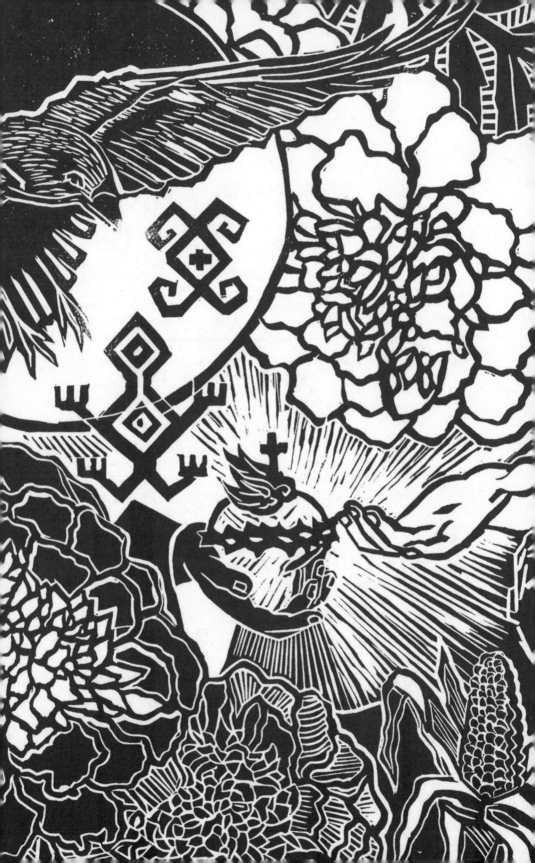

Courage together (lamentations)

Indian Shaker Church, thank you
a group of creaking chairs
human weight aches heavy overhead Wood
beams in the shape of the Cross

when no one could did help – no doctor, no principal
no nothing and no no one, goodness how i tried
though i stayed mute, i did see
not hear Truth, Sorrow, Regret, Desire
while we Sing, we Stomp, my body Shakes as do Bells
our Cries, Prayers, Lamentations

Testimonio from the island
former yet faces and Stars peer in from high-up windows
candle Flames slowly burn warm to their ends

my daughter's old man beat her up, mama said
that was so hard for me to take, she said
lady, almost dead

i didn't want to be here anymore, he said
they gave me more antibiotics, no, antidepressants, he said
i haven't taken mine in months. it's just too hard

someone cried, threw up, screamed
i wanted to do the same, and more
everyone is open, ready, generous
you take this part, i'll take that we do until pain
is all burned up in candle Flames, foot stomping, bell ringing
someone pointed at a chair in which i should sit

don't look at me. don't see what is in me
don't know the things that make me
not scream, can't cry, not want, any more

why kill me?

no one needs a Venerable Cedar, Sequoia, RedWood, Bristlecone Pine
in their wallet, flatbed, toothpick, old
reap and rape is not economy it's collective suicide

Elderly Cedar, Sequoia, RedWood, Bristlecone Pine, Their
Work is necessary where They stand, for as long as Roots root

loggers photo-brag, their chainsaw posed as if an erect penis
this is no allegory

misogyny's purpose, to continually, consistently, destroy Her
my Mother is a Grizzly Bear made up of Red
Sky, Red Earth, Red Blood, Red Roots
She is Mother Earth

why are you so sad?

suffering, Wren
not a Worm may win

stop looking at me
look at this

clear-cuts, eroded land, sunburn windsweep
waking up yet alive
loneliness, species loneliness
my Home is lovely lonely open re-Make re-Do
unRavel weapons of terror

i want you, darling Water, FreshWater Pearls, underWater
Monsters made for Here who grab up and bring down
floating shimmering Fear, Love, Beauty, the Courage of we

Rain's Black days, living in a dark house
my eyes, my heart, missing
warm hands, where

Seagull (smash)

tail feathers fanned flat
final rest not upon the high Seas –
upon a dusty bed of tar
muddied paper-cup grave marker
bloody oil

left wing folded, a closed hand grasping the last moment
Sun beam, Mother Home, Sardine runs, Lilac Breeze
right wing bent, splintered, an after-death wave, hi hi
although he is far now, past the Himalayas
to the Other World

flutter, with what once were cleanest clean
reflecting the Blues of all Skies, Greens in all Water
swept up by wind made by passing car tires
pesticide Butterfly Wings dropped
we, trash, mix with sky Ashes, Plant Pollens
Cedar bits, dried Pods

Gull, your Heart deepest Red amid
auto oil, sticky smut
one tick-tock ago you Cherry Honey
shiny wet, as if dropped from an open-mouth baby Bird

with your broken body, but intact insides
are you feeling, still? this worries me
am i feeling, still?

Branch bits splinter, car radios beat
misery – the type only Love and lack of
can may does cause

stay your Shore meditations
may we undo our past
re-Make Sanctuary

ukʷnaqín vancouver

let's melt let's fly, search under Shore Waves for
polished glass salted Stones, only coloured jewels
when covered by Waves

Hawk's precise lessons in song, some think belong to Eagles
Echo Mountain Valleys, Fish and Bird beak-tongued River bottoms

three Falcons circle over four Red-barked Pines
Grasshoppers click, baby Birds gape, Insect broods full of flickering bites
their smell is intact Cleanliness

Sap smell as holy resins, running to Treetops and Roots
today's hot Wind embrittles hair, skin, Twigs

Crow tries to sound like Raven, and Raven answers
i have no illusions i will last
more than one more day

ii. Lightning Strike

Seagulls stare knowing past, future, intent
unblinking, they tolerate transparent muscles and bones
sidewalk, Beach, ground, park, alleyway
all receive Gull's deliberate meditations

Gull says, *may all be beautiful*
Sandpiper says, *i am hungry*
Oystercatcher says, *find peace by feeding me*

stale Bread, Crusts, manhandled handouts
Bird faces having hoped, always trusting, still
trusting, for small Fish or Seeds, these from now-endangered species
in these starvation times

all i have to give is cheap and quick
Crackers, stale Toast not made into a pudding
Love. it's kind of them to take it

iii. the cost of admission

her Home is gone
perfectly destroyed

technicians in orange safety jumpsuits
engineers' instrumental religion
giant trucks like small mine-makers cruise the ever-widening road
driven by solo men
who must hop up and jump down to get in and out

it isn't concrete's fault, as he is forced to spread, made to cover
every bit every last one
trapping Moisture from Dirt whose Holy
destiny is to make Rain, Fog, Clouds, and Holy Beings

more
is an endless onslaught

iv. we

BumbleBee's expansive Garden is every
Flower who has ever Lived

Hawk's day/night sky, n̓x̌ax̌aitkʷ (Ogopogo's) legend Lake
their family backgrounds, our shared story, we are all Related Relatives
ask any Blossom, any crawling Being, any tall or short
who it is that you Are

sore back, burned eyes, torn tendons lead to your Home
Flicker Garden Homecoming made with
hands wrinkled as Eagles', Seals', and other Helper Beings
return of House Home is independent
sovereign Labour

v. a new way is possible

more. i give you this kind of more
open your self Land Air Water beings
today, amid bleached Grasses, brittle Pinecones
i smiled at you, Grasshopper, and you then, at me
stay, so i may take your picture
you did, your enlivening heat from broken
Rocks upon Whom you love to sit

smile, please. your spindly arm waved, *oh hello!*
you rubbed your Yellow eye as
a Kitten washes her face. *hello Kitten*

when you hop your arms transform to White wings
are you a Bird, a Butterfly
looking in Air somewhat like a Moth

Mountains once were Valleys, under Glaciers
Lichen, Mosses, perfect sense, Ice and Snow
Sun has been here through all our manifestations
Shadows make Trees long, then short, and wide
we, Bees, make our Garden Homes

vi. i can see you

there were villages all along, he swoops
his big old hands across this hilltop view
we had our lunch which i didn't like
i fed a Duck Potatoes, because she walked right up
to our table

the place was full of people drinking just as in orange county
i too left that place as it had been in ruins my entire life
i am in Indian Country, amid a growing city
looking for Grizzly Bear tracks, trails remaining between
rolling hills, as Land always recalls her Sons and Daughters
what was this valley like? not that long ago

i dread dark ruin, humanity's onslaught
big-box stores, all the rest, of all Life Lives lost
i dream of *skíṁwet* Tiger Lily, our great Forest
the breaking-through this greed sickness called empire

vii. our daily (drugs are a colonial imposition)

street corner's box full of
plastic-wrapped Bread opened by Gulls

fentanyl is taking community members, moms, and dads
i can't rely on seeing those precious smiley-faced friends anymore
just because i bother to show up

where are you? i ask
as i ask Sasquatch Protector when in the
real Land

i have missed them
i miss you
i will miss you
life is short this way

memories (after the mission school)

i would Pray, hold my breath
not to make the slightest sound
sometimes i fell aSleep

i recall our special smell of dust, darkness, quiet
our Dog often sat by me, awaiting relief
a stack of old books inside a closet corner
upon which to sit, hidden by hanging clothes

she said, *i am leaving all of you, you can all go to hell*
i wondered, as i scrubbed the bathtub
she lamented the place she left, reminding me, always
maybe she thought i couldn't understand, but i did
or i wasn't listening, but i was
go away before i throw a shoe at your face, hers curled like a fist
what had i done, this time, every time

most days she would come after me, heavy-footed
hunting, to scream, hit, tear at her hair

she said, *i hate you*
she said, *i wish you were dead*
she said, *get out of my house and never come back*
you should never have been born
you should kill yourself
i believe her

children's dreams, what will i be when i grow up
i dreamed of cutting my braids, packing teddy, off to paris
i only knew it was an Ocean away
i love to forget

my mother scolded, *i never wanted children*
i stood there, wondering how to sew a button on my doll's dress
worried she'd be cold as Fall Winds blew
outside Leaves scratched sidewalk, and i thought of how i
love to run

not lying down

for our precious niece, CM, GP, and MC

Altar of Relatives, for all Relations, KinFolk of all Diversities
Flowers, Tobacco, Spirit, Here
we have come here on this anniversary to make, set off, Free Prayers, Love
in an industrial park feet from a mini-mart where cars fill

this, where her niece, mother, BeLoved, young, beautiful, good, somehow met
in a twist of the worst, a soccer coach, murderer, torturer, family man
he is why, MMIWG
when shall we take the lives of women seriously? when will Women matter?
Love Mother, Love Mother Earth

delivery trucks are backing in next to our space where we have
placed Roses in the shape of a heart
a coffee can full of Sage watches, knows, carries
a steel pipe drips precious doctor Water
a shock of brilliant green Grass bursts along concrete steps

we are terribly remembering, careful. drivers nearby see, concerned
our man Sings with his Drum, Eagles gather
we hold Cedar Boughs, together with a telephone
line row of Pigeons who quiet their cooing, keen
their teeny heads as witness to all we are putting back together

Crows know, settle down
our steps lie over twenty-four-year-old footprints
her former feet who walked, ran, dragged
she just needed bus fare Home, she was targeted then
now she is Free, Blessed, Honoured, Loved

we will never stop Loving you
we will never stop Making Justice Real

we are here, Witnesses, memory makers, Justice seekers
Eagles fly over us now, we will always remain

ii. NoBody

for Anonymous She

Sister Friend testified in ◁σ∫ȧV Anishinaabe Territory
it is safe there (heavens! i could never, not done so, here)
away from vancouver's serial killers, their organizations

their police, their rcmp, their judges, and their courts
their names, forever polluted, forever stunk
by invisible graves, potted Flowers, renderings
everyone knows who

iii. Defenders

Galaxies, as Water Walkers, Snowshoers
Water, Snow, Sweat, Respirations
Circumambulations are Forever

Yuwipi appeared, speaking of Susan
Yuwipi found her happy in a happy place
Yuwipi you are needed
Stay, BeLoveds

i will never tell you her name
Sister Friend cried, *until this hearing i was nothing, no one heard me*
many of us street-weary, man-tired Witnessed
the commissioner's laughing dismissal
one family screamed at him *LIAR*
Community Nurse said to his ugly soul, *disgusting!*
upon being implored, *all you have to do is say yes*, she begged
publicly, openly, he laughed at her, survivor of the farm, at
we, our best, brightest Women

Ruth knew his life and spat on the ground
what he knows and whom he protects

Kúkwstumckacw Elder Sawt Martina Pierre's
Lílwat Women's Warrior Song, first given in
Sweat, Lodge, Prayer, Vision
all the World Sings

foresight

my teeth slide as i Sleep
whoosh out the door and become as Birds
fly far for Desert CottonWood Ravine
to find Wild perfect Seeds, grinding these, smooth
Marigold, Daughter of the Sun Butterflies, Milkweed – my
dreams as a Bat, a Tarantula
a Spider inside the spot Leaves join Stems

Sanctuary Home – it could be Mars, it could be the Moon, no
it is here, my BeLoved Long-Needle Pine Butterfly House
Planet, Star, Comet, all of It

i should have married Mr. Daily the day i found he
was terminal, calling on him, and there he was busy building a Coyote fence
i should have drunk myself to death
but i ran and ran instead, injuries, pain, no matter
i could have run across Mesas as do Stars, joining hopeful
maker, Spider Nebula
the space where my heart would be
with no where for these Wild things to flee

the teeth in my mouth are sore
as if they decided enough already with these Apple cores, Corncobs
satellites, space junk, clang, their litter, falling and crashing
we look to their falling fireworks as if majestic Christ alien
but they are ashes

do your ears pain you, as mine do, while
a man circles Saturn, a flag pretends it is a Tree on the Moon
roundup-ready settlers on Mars
i can't wait to go, he says, being human, proving again, my
mis fit mis heard mis take. i think i know something but i know
nothing especially of star wars, weapons of mass destructions
i will never understand this world, his

over his shoulder, out the window, calling
Foaming teal-Black bay
peninsular Land ends
Sun slits, Silver Clouds

flawed

Forget-Me-Not bundle, tied with a ribbon
attracts neither Bugs nor Bees to
his car trunk

Flowers' BeLoved perfume, colours, design
taste, Pollen, Tiny Homes, their
Blessings, Sorrow-Soothers, they are Fruit and Life
but these, forgotten souls, have neither smell nor vivacious flame
with which to call in Dragon ButterFlies
their perfume and florescence vanquished when trapped in a sunless cage
they are presented shrivelled, hard, their energies
suspended between this and the World of the Dead

he says giving me Flowers i must feel satisfied
he says i should feel first in line for having
gotten this wilted bundle, itself a funeral
limp as a Rose left directly in Sun, incomplete as grave markers
isn't there something else they should say?

we Flowers, me Love
wilted one knows that i know how to bring Gardenia back to Life
we Water, we Coo, we reject the trunk, the cage, the plastic wrap
my House grows many for any all Fliers Crawlers urban Dwellers

remains (when faithlessness demands proof)

look, a perfectly clean
skeleton between bunched Leaves, crawling with
feasting resident Bugs

Snow-White leg, gnawed by Winter Ermine, Mice, Moles
comforted by impermanence
compatriots' Lives ritualized by teeth

see, scattered Calcium
our slimy, red-Leaf, open-Air tomb
he, a little peekaboo for you so you may be Blessed

Snow bones glitter as if a Stream, when all is Frozen still
Life moving as do Clouds
transforming shape, Shine, our unknowable bits

i remember my old frame
the way my shoulder bones stroked high-bush Cranberries
my Spirit song warms

our universal blood brings us to this
shedding of skin, Velvet, matter, and yet we inhabit
Dreams, Visions, Watersheds, Rain
we extinct phantoms for whom streets are named

our dirt has run out of Phosphorous
it flew there to where with the Wind, plow
mechanical uncovering of Earth's tightly Woven Shroud
Flowers, Mice, Ghosts
Embroidered amid Roots and Worms

what will Plants do without you
how to consider, plan for future Plants and Bees
remember, our skeleton
Crystal, Mineral, Plant Offering
our final gift
to lay bare atop Soil

tiny Ants play mouth games
with Wolves

disruption

when they said we would break all heat records and the Forests would burn
we were already witnessing the drying of the big Trees

what may ever silence this terrible grief for You
multitudes of Holy we call *Our BeLoveds*

Summer burn smoke so gritty people cool their lungs in hospital
there are no hospitals for Deer, Sage, Grouse, Scurrying Ones

Home for and of Velvet Viridians
more than twenty-five degrees above highest record
RainForest denial, Call Now for Wet, Rain, Cool

Monk says, *forgive the high-seas pirate reaping and raping*
children and Elders, but i and my Sewing Awl
Weaving Axe do not

ii.

i Water my Garden twice a day. big Purple Leaf droops completely, given up
yesterday i took medicine to not give up. i give her/him Water and i
tell them it's going to be okay
i drink cold coffee and say i am going to be okay, but
who am i kidding, it is not okay
there are no Bees today

please drink your Water, eat, have your Food
i tell dried Plants not to worry, to re-Seed, there is time to be alive our
BeLoveds BeLoved Planet. but they are gone
Forest Understory Plants, who have been thriving for generations, turned
black yesterday fine in the morning
dead by evening, she can't/won't live this way
god, i know

delicacy

don't ever call me that, he said
looking nervously about

you are a connoisseur's delight, she said
he hung his head
he who sets that metal plastic trap
hunts me and mine and
we must flee from here Home

my relatives, those whom i resemble
and those i do not
we burst open inside as we are pulled up in
nets and hooks

we try to Breathe in your world but alas –
suffering, statecraft, conquest

you are as sweet as pie, she cursed
no, i am a bitter Apple

ii. i am leaving you

Salt Woman is but a memory of a former
Salt Bed, as those who defiled left filth upon her Sacred Shore
She warned, *because of you, I am leaving*
She informed, *because of your acts, I will move away*

what to say (archetype)

when adult men sneered at the Red lady walking with me
i wanted to hit them, bite them with my large front-gapped teeth
where did you get that Korean baby? – pointing at me

stranger male against short Woman, it's always this way, nothing ever changes
my sister was blond at three ... the times
men offer/ed Mother cash
ode to the manners in which my Mother fought/fights hands off or
i shall and you will die

every day a new threat, on the bus, out walking, shopping for Food
men attempted to seize her, she as enigmatic as the five Dark Days
black-eyed hum as a BumbleBee, unpredictable, fierce, frightening

she'd walk on, no fear, her Powers made them invisible
if only i could fight them, i wished, a child with immediate hate hit
vows of non-violence mask what lives beneath

hate is a terrible thing, Papa would say
Jesus and his insufferable non-violence
they both, better, Best

now i am an old woman and the mama i walked with is
in the beautiful Sparkling World

wealthy squatters build massive houses, motels really
working poor left houseless
mines make colossal geologic holes
were you able to eat Clean Food today?
there are so few Salmon left
oil chases out Whales

man overboard

container ship, imposing atop undulating Waves
saltened brooding expression-filled Ocean is witness to
many Mountains' sliding, roaring, clear-cut down the drain
no One may grow

Rain needs standing Greens to
be Rain, not flood, as Salmon, Bear, Ant
need Swim, Climb, Run without drowning

Waters' eternal Ceremonial transformations
Earth's Ice Peaks, underground Stream
Watershed, Aquifer

from highest vista towards SeaShore, Rain travels and re-Makes
for many Nations of Trees, Shrubs, Ferns, the time of the Dinosaurs and what
is coming ahead

clear-cut massive Beings in steel boxes, stacked on deck
bleed RainWater, Soil Nutrients, Dreams of Ancients, eternal Memory
out of chainsaw wounds, into Sea. a view from international shores
a postcard of humanity's horde of urns

bridges roadways slash-and-burn war "economies"
burning material yearnings –
damage wealth security
no contentment until no Soul remains
tumble dissolve as does man and all others taken down

high-swelled Seas attempt to buck off these
humans, we know this way is wrong, but keep on
doing it, just do it, call the rcmp to crack heads jail maim
we load another ship full of our ancient Elders
we shall never meet again

biodiverse Brothers, Sisters, metal passive doors agape, squeal, metal atop
metal beside metal worked thin to rust, beaten, holders of
human cargo and dollar-store bling
uncomfortably full of packaging, disruptions, tubs

plastic, plastic, what Prayer may i offer
what miracle shall i beseech
within everyday Miracles, compared to the usefulness of Soil

the ship falters Wind blows Waves hit
we are being watched by dejected containers they know
passively, each new or rusted says, *i don't want my life
i do not agree to this back-and-forth to-and-fro, the
cutting down and gathering up, abundance laid to waste*

where there is no end to suffering every one
one at a time, filled transport cart each metal box, done in
knocks over another, skitters, shoves, in turn, slides into Ocean, to
travel solo, ride storms, sink to sand or surf near Shore, breaking on
Rocks, scattering Shorebird Nests

there's a gaggle of new refrigerators thrown up
remote Island Shore, a slew of toys akimbo between
Beach Boulders, newsman says, *do not touch
they are polluted* by the magnificent passive One
they are only wet, salty, needful

Mother Earth, Body, Blood (bioregion, commons)

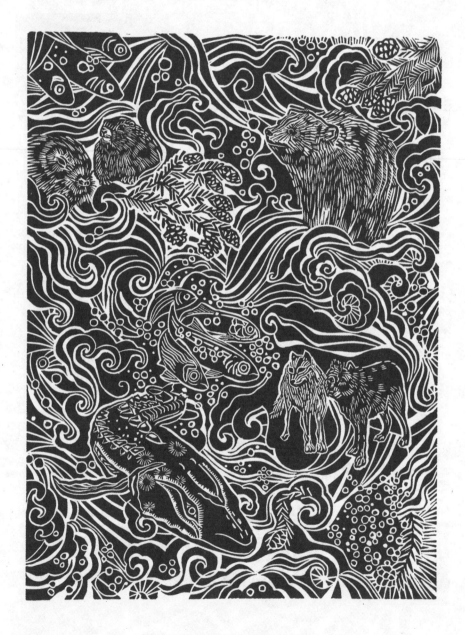

constellation, 2021–2022. Relief print, ink on paper, 18″ × 24″.

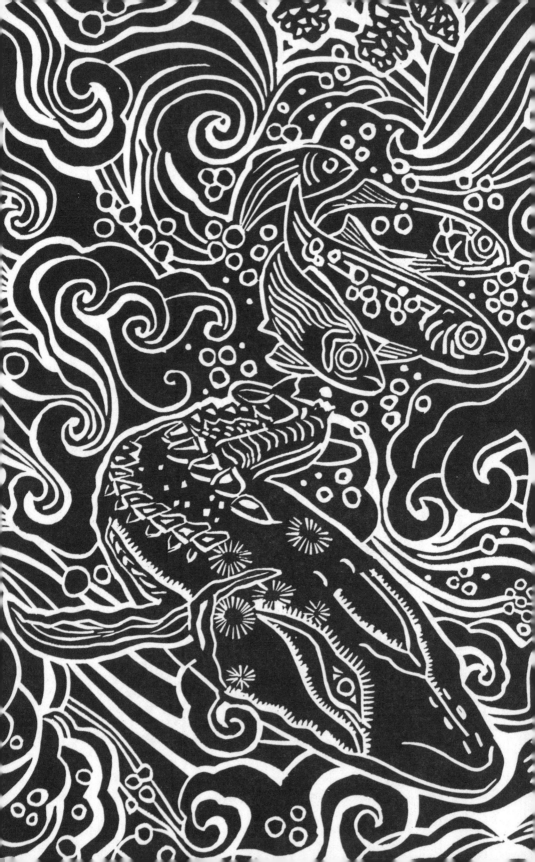

River Slush (how our Prayer started and finished)

Bear hide floated down the Spring-breakup River; Red root Red blood
i don't like these days when all Food turns to old newspaper at my lips
Sky droops, opaque with heavy Souls

flesh heaps rest under frozen Ground, as stone is Stone
awaiting a rapture that shall never come, already came, did i miss?
we are left with this underground Spring Seed bassinet Redemption

Rain, while Floating, Falling can't decide to Freeze or to Pour
is this my last chance? she wonders, *what should i be?* if this
her final performance. *i can never be here, again*
i will never come back. don't even try to send me
how bad will things be? tomorrow, when today? today

SnowStorm, Blizzard bite, dark gloom
Ice sits in limbo, not melting not breathing. *i want to stay here,* he says
road dirt car splash blackens his clean Spirit face
no matter. soul is Soul, ice is Ice, mud is Mud, clouds are Clouds

i called Robert because the Ghost who doesn't exist said
call Robert, he was near Stikine
Bear-skinned skin, moving swiftly in circles, amid floating River Ice
we both wondered, as if a song, dear Bear
where is your Blood flesh, your miles of Red-woven veins?
are these not your days of deepest Sleep
of Bear babes in arms Suckling at breast
of dark Caves, Fern beds, Solstice, full bellies

Robert turned back to cross a steel bridge, to look again
where, your head? where, your hands?
who sings your Death Song, Lights your Three-Day Path
who places Flowers along the Holy Trail, precious Berries in a bowl
for You for You
i for You

ii. altar

Fish-head Altar along a Beach
Seagulls, Wolves, and Ermine, Our Holy Communion

your funeral, Animal Sanctuary that is
our beLoved Woods

open up
Mourning pours out and over as does Fog
my rust-Blood despoils machines, jams guns
covering these killing fields with Strawberry jam, sweetening the works

iii. Love and be Loved

Tiger Lilies, Blossoms' Earth Work complete (for this round)
their Beauty rises into Orange Sky, Red Horizon
long-Veined leaves, left behind in their Wind-Wave, *see you later*, stand
fallen, dried, sorted last Summer, bundled, swaddled
babes in the manger awaiting their basketry Reincarnation

early Spring new Snow after Buds already Awakened
Blossoms along the path, her Elder relation, old Snow, gathers, clumps
new Snow lights her path, clears his way
to Fog, Stream, Ocean, transform

Robert snaps a photo, this Bear a wasteful tragedy
Sorrow is our community Meal

Life for all Living Beings is our only Prayer
liberation, emancipation

stop killing us our mantra

on the diversity of Clouds

Rain is falling, Glittering my Emerald coat
Cedar, Wind, Souls from epochs past inhabit, arrive
a Black space who once held an Eagle's Nest

i gather my laments to tell you, Night, of the broken Bird leg
i speak of all day
incredible Shine of full Moon's Silver Shadow-maker
humans have nothing for me

i have been waiting all day the ditch, the bed, the cannery

Fish Eggs in boxes, Fish Egg between Stones
Fish Egg swollen on Shore between a Gull's flat feet

we are eaten by Herons
gulped by Mice
carried off by Ants

Birthing Trees

is this the right time to gather Roots, we ask Moon, Dirt, Air
they are clear-cutting even though we all know
there is no reason, ethic, moral, rule

set to gather Roots, we slept poorly the Night before
nightmares of tired Winged ones with no more Nest
we, on a mission of salvage, for our Lives to have not
been lived in vain

i don't want this war
i am your remnants. i will not appease
you and your hands with my weaving

though there are obligations. Roots call from UnderGround
broken from their bodies
who is left to carry on their treasured lives? we
trust you with our babies

Clouds who are Holy Beings, thought about being Rain
but then brought their Gift elsewhere, where Green limbs
wave them Home

i was relieved, knowing Mud slides
when Trees are no longer able to
Hold on

autopoetic biographies

i. philosophy

what do we mean when we say *Sovereignty*, Rights of every Thriving Life
Rivers, Water, Bears, Bees, Cleanliness, Health

ii. purpose

smallest almost-Insect, while inside her
glossy Golden bead head-of-a-pin Egg
sees Life as EverGreen Garlands, Meadows, Blooms
how does she know?
we do know our first meant-to-be flight

dreaming alongside other Shimmer-Bead Visionaries
everyone decides, one day, the Bead that surrounds me
will be every Being's brightest Star

iii. security

Fish Turtle Mother decides carefully
baby's bassinet among polished River Gravel, Beach Sand
she recalls from her Mother, GrandMother, our
original instructions via Tides, Moon, Salt no Salt
thinking of new Salmon, or a Salmon turned a flier
he spreads his Matter, enlivening
wake up, Wake up, awaken, Darlings

iv. Daughter of the Sun (her other name is Monarch Butterfly)

Bead-Egg now a Caterpillar, eats Leaves he is
born upon. so small she can't go anywhere else
Bigleaf Maple, Parsley, babies' *x-mak-ulam* (Milkweed)
breakfast, lunch, dinner
bitty Worm sees Cantaloupe, Big melons, in their future
while growing slender straw tongues

v. Dream Maker

Birds and Bugs fly inside Kinnikinnick's branch skeleton
Blood circumambulates feeding Bones. we join
Grouse, Moose, Leaf-eaters, Bears, Bearberry Fruit
no one breaks

vi. Guardian

his diamond-patterned body side-slides across
rotting Leaves becoming Soil, he Prays, may every
one get too big by eating
thanking Slime, skin sheds

he bends his impossible neck, sees Bees and
decides, understands, despite Sky and Burrow
watching flight, its circles, spirals, turns
a Dragonfly, an Eagle, hover

vii. Holy Beings

Soil's mannerisms, her birth HomePlace of all
Rooted Beings, Worm place Bug house
Mouse house Beaver dam
transforming energies grow Plants
mica, uranium
Life's laws are held in Mother Earth
She decides up, down

viii. what comes first

Hawk decides it is the egg from whom he emerges
into this, will it be for better or worse
our strains, our many-Winded sorrows
she will not miss these Magical muscle pulls

it took so long to be here, you and i
Beans, Antelope, grow up watching
changing of coloured Clouds

ix. tomorrow today

every form, every manner
despite human destructions, impositions, cruelties

what brings Squash Woman forth
also makes *Forever without End*

Butterfly House, Dragonfly Dream
of Flying, Fluttering, making Real

Dreams are alongside
compatriot Mallows, Sturgeons, Swifts

Ceremonies, Ceremonial

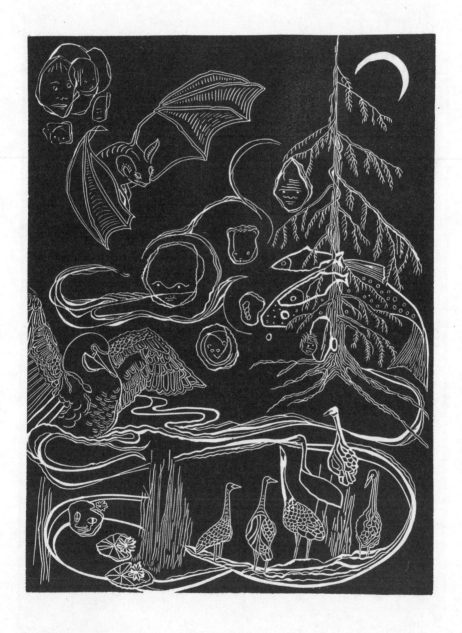

hello, 2021–2022. Relief print, ink on paper, 18″ × 24″.

Fish

Salmon-head stew with Potatoes
cooked over a DriftWood Fire
Red-Yellow Flames against a shallow Shore-Cave wall
this Frozen, Winded Night of the Black Hero Twins
all together with/among a Winter Squall

my friends said they would come
i had gathered every thing gifts
flowered Clay dishes, spoons
mixed styles from second-hand stores
Bread, all nested in bundled fabrics
napkins made from an old festive tablecloth
and blowing Sand

although i waited and the island was small
no one came to this, our Holy Observance where all is
Aligned, Present, Good
tall CottonWoods along the Stream let loose Leaves
who Spiralled as Stars above Glimmer we, our intertwined

our only Friend faces were in the pot
and mine, and we did as we must and promised, watching Stars as
were watched three thousand eight hundred years ago
this Night shall not come again
for another three thousand eight hundred years

North Pacific Wind rose as the Sun lay down
and blew out the Fire as often as relit
Sand became like perfume, draping, Floating in Air
a Red Fox watched, making a suggestion
reading my mind, faithful, attentive, Helper

in return, i left the Pot behind, Open
for any every hungry Soul

may this Food multiply for all Living
and all dead

why fly?

why do Eagles fly? see Her circling, smooth, sail
see Him? open, wide, invincible
You in farthest darkest unreal Places
easy in Homes of those Who are said not to exist (although we do see them)
You fly high at the MMIWG march, above city traffic, crowds
we Drum, smile, Howl out to You, and you reply

Her Care
carries all
our cares

why did we put this upon you, Sky Swimmer
do you need a rest, and may i Sleep for You, as your job
i can never match

why fly? Wind, village forward, city back
from bell tower, to open Ocean
Mist-riding over Waves, your Gifts bed down in Bones' Marrow
our bodies, our hair, You, Your Work

Winged Dream-knitter, Feather winds stitch, joining Ravines
Emerald peninsulas, Sapphire bays, Old Growth, Understory Ferns

why fly? great Heron
You kept on, You make real, with your heavy open arms
we are re-Making Marshes
Dismantling dams

Wisteria

last Fall's Wisteria Seed pods float from strings woven themselves
Elder anchors upon Branches who would have been pruned
away as humans cry for
neatness, civility, proof of our training
even our Plants, our Red-blood Nature, expected to submit

heritage Tomatoes, tangled Flowering mounds
Wild twists of fate like Hurricanes we are meant to survive
thousand-year-old Corn upon an ancient Tewa shelf, looks out
across Mesas, meditating as do
crumbled Stone houses, Moss-covered Homes in Tree limbs

every Third day, Lake ascends to furthest Heavens
the top of our breathing Home
Souls lost to empire and those from before
ferocious beings, gorgeous ones, binky babes all confer
Lake bits bind, so they again may Garden
our bodies
hardened towards Snow

who cares for Feathered, Claw-footed, Beady-eyed beings
Nature, Mother Earth feeds
no longer are they as wide or deep as their Sky-darkening kin
no more bridges across Rivers made of Fish
promise of Food prior to industry's revolution

who fled the machine, where is Easter?
we are all indoors
wearing masks

i have a headache. i am teaching
a class. i had Toast for breakfast
this is why it is never about me
a billion Stars

Flurries

neighbours hunched over in Feather parkas
unknown names, hooded faces
Geese are either in warmer climes or being plucked
Snow has made Dark Light and Light Dark

indoors with Sleeping Dogs
i sit, watching their Dream exertions
it should be me, it could be me, running
but never is. i hide.

Sister today entered palliative care
the border is closed. trucks cross everyday
mcdonald's workers cross everyday
everyone is fine but i am
stuck

wet Snow
Lester delivers stove Wood from Paco's cabin to Mike's
heat for our dying one, her child, grandchildren, niece
didn't they want a Puppy?
where would our fledgling go, after her flight

i delivered Feast Day Stew, and i sat and sat, listening
here by my window i await our neighbourhood Eagles
or the Red Robin i saw only last week, despite this Winter
Green Black Clouds shadow as metal tools scrape concrete
not deep enough to shovel, too deep for certainty
one block from here
roads are clear

my drive is covered and i think it would
be nice to have a Puppy in my parka
to help with all this. i could do it myself
but i have tired of practical, futile acts

Ray's body, found outside his condo, shovel still in
frozen hands, having left while clearing a Path
Black and Green hooded ones lean on shovels, talking
there's a pandemic, someone said, the very least of my
concerns

let's light our hair on fire and
curse our dark and lonely selves

Flower parade

we are so broken and
shattered
how will we ever be put back together again

at Mike's

can't find paint, out of paint
didn't even think to find paint –
too busy making soufflé Pumpkin pie Ginger cookies Meat
Meat is not my Food i am Maya
Corn Squash Beans

culpable, i am complacent with cruelty meat
trying to feed hungry kids who don't know about
factory farms, bombs, the man on Mars
their grandmother Mother bald from treatment

they are in hiding. i never bought paint
i am out of yellow. and nothing else i have can make
Yellow, like Red and Blue make purple
yellow is Yellow – Sunflowers, Clouds, Stars

prison looms over son, but we kick the
soccer ball in the living room, shrieking
long-legged Daniel catches every errant one

Ghost Vulture appears perched near the couch
head down eyes following
Earth's cleaner has a Magic gut, as nothing ever
no filth can or may make Him ill
we know his Spirit is a good sign as we stave off death
with kitchen Fat. eat it, i mean it. you weigh seventy pounds
all things Corn put Flesh on all things Bones

we were Planters, we were Makers, Counters, Watchers, Healers
let's do that all again. we all
cheer and agree over cake, of course, it must be Cacao Chocolate
heritage Indigenous Foods for Spirit and every/all the rest
Living Beings

votes ignored. labs turn out viral disease
Blix's team named these biological weapons of terror
if i think of this, i am so beyond grief i
eat styrofoam the only thing
that seems to last

as i awaken (Bear)

when i finally awaken, my face
my hands, my every bit and Being Ecstatic to
meet my Ice-Melt Glacial Streams' many-branched arms, their
downhill races, cutting through Clays, Pebbles, Sands
we've made these real from the time of the
Earth Birth of Mountains, Valley Floors, those Who have do
shall never let go

my Cave, my Moss-and-Leaf Winter bed
BeLoveds, my best Dears, where i slumber after much many
Meditations, Moons, Makings

Earth's babies inside Rainbow Shimmer meet
Water who is Snow up high and Rain on
the Garden. hello. look at me, Breath remains along
Animal trails. there are Places not and never meant for humans

Swallows pilgrimage to capistrano, remind, recall, and remediate mission's
labour of slaves, slaughtered cows, and other
suffering Beasts. i am a beast. i am a burden. i am a Flower
re-Made as human to be one day a Cloud

Dragonflies bear witness to rip, tear, the falling
smashing of grand ascendent Hemlock, Salal
a chainsaw is a screaming maniac
rallying we

exhausted River alight, modern landfills are sanitary
cells planned this way, to mine after all is
trash. the coming days of want
tomorrow's grandchildren sift through debris
a bit of plastic, a rubber
band, only then shall we lament You
original Beauty. i know you are here, here, deeply

erosion by Waterfall, a restful gathering of White Butterflies
earthmovers take apart all grandly intermixed together
newspaper buried may be read forty years later
is this the only way we
can recall our
Forest Blooms

Reconcile, Remediate, Put Back Together All Whom You Have Broken Apart

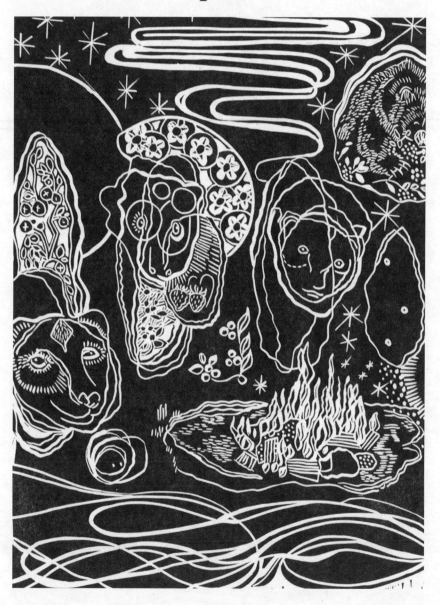

Untitled, n.d. Relief print, ink on paper, 3″ × 5″.

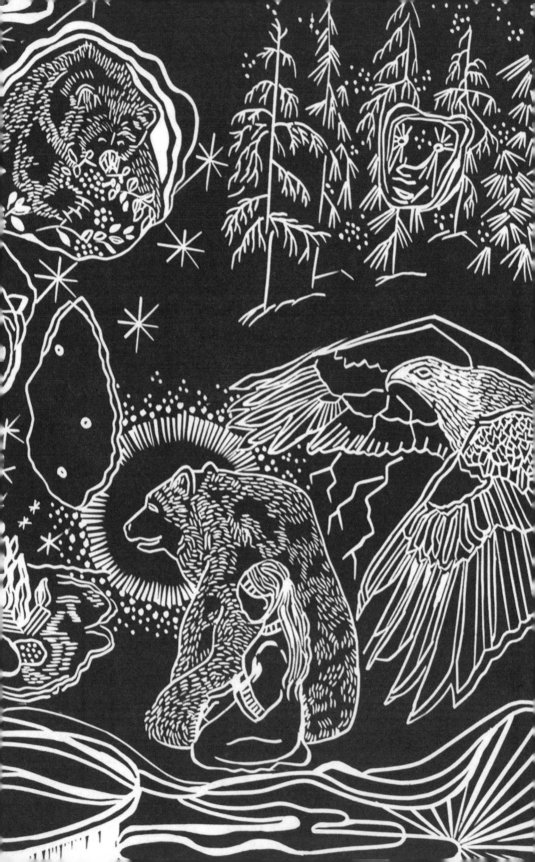

i am a liar

remember when they said certain folks must
live apart from other humans
those people whose hair turned to Snakes
the ones who saw tomorrow
Healed the sick from Power shared, our inner
outer, all around, Beings
those who knew know Whales migrating with Hematite
charms, Earth is one giant Amulet
could suggest
when we should or could come or go

we are told we are nothing, in our multi-galaxy or flat
Earth atmospheric scheme
employer pontificates, we are all replaceable
another Sacred Mountain Goat, Grizzly Bear family, extincted
the myth of sameness, lack of consequence, all a colonial lie

chainsaws' horrid call – squeezing hearts, making orphans
gas fumes chase all Living Beings far away
deeper in to an in that no longer exists
so we run in front of interstate trucks
shattered

Elder Yellow Cedar and his/her relatives –
i can't not fall. violence hacks away as if i
a broken Stump – not the type for a Red-headed Woodpecker to find a meal
the type dispossessed of all that made me
useful

if we Pray for your return, Sacred Lives, where
will that be?
re-Make, re-Sanctify
hello, welcome new Grandchildrens of all Species
we are now making, saving, revitalizing your many
House Homes Holds Strong

fifty thousand interwoven knots our Mother, Earth (therapy via empire)

i don't want to talk about it. i don't want to talk about it. i don't want to talk
about it
idontwanttotalkaboutitidontwanttotalkaboutitidontwanttotalkaboutit
god i don't want to talk about it
stop. never ask me again. didn't i already tell you. stop stop stop

ruined home, tourist trap, your golden ticker
you erase all i think, feel, remember
Witness Bear Believe and this will
never be expunged from every historical record
Rocks remember Hands and recall our Names

can you hear me? the room is whirling with your modern absurdities
attempts to supersede cheapen Sacred Life never replaced
what colour are my eyes at Night, as we wanderers between Worlds
no. no. no. no. Indigenous Rights are, in part, the Right to say no

stop fixing me to be like you. i am not fixable. there is nothing more to do
if you are so right, why can't i be okay this way, when empire did this
i refuse to end my furious Love

what is so wrong with me being so wrong?
interconnected, intertwined, can't i just be flawed like this?
addictions, depression, suicide are colonial impositions

crying at deaths, those taken before their time to go. someone who waited
one billion years to manifest alongside Roses and Thorns
i can never paint how i feel for you, this is
not my aesthetic crime

stop fixing me. i have no time. it is too late. oh won't you leave me alone
i don't want electric shock i don't want pills i don't want a vaccine
we are all related
don't ask me, i won't answer
don't tell me, you don't know
have you ever, did you ever, know? no

it's ugly in here. someone designed a window never meant to open. someone
made Mountain Goats extinct. someone decided to murder girls. i am meant to
smile smile smile

don't talk to me, are you listening?
i am so tired and i am fed up
Ya me cansé, Ayotzinapa, Chile, Thunder Bay, stripped mountains, diseased fish
it will only end with *we*

disheartened

why ask of Them
that of which i myself am unsure?

drink Water, eat Pollen, it's good for you
is it? ask a Bee

a perfect Peach, a hungry Towhee
green Figs who never ripen
Corn half pollinated, then the Frost

some people fall in the Lodge and then eat Berries all Winter (a psychiatric assessment)

i have been reading your file. i know everything. there is so much to read. please answer these questions as honestly as possible. the best answer is no. if you say yes, there are consequences. be as honest as possible.

Q: *have you ever heard voices that you cannot distinguish, as if they are sort of in the background?*

our group as close as humans may be, gathers
a city apartment, completely blackened room
voices of diverse notables, back from a scaffold in a Tree, long Petrified
knocked and swung hanging closet doors
in old Dakota, B joined their Whispering chatter
men and women spoke to him, as if on the opposite side of a fast
Boulder-strewn Stream

out of the Dark and into my lap, heavy like a Pebble
startled by the landing, i gasped
Robert said, *don't be afraid Meow Meow, it's only Spirits*
Wind's song filled the Air, but there was no Wind
patter of heavy drops, Hail, fell on me, making noise
i held out my open hand to touch, but there was no Wet

often, in the Night
i am Dreaming but not dreaming. i hear, read, write entire texts
sometimes these words are spoken, or sung
in daytime imaginings, an old Soul who is the Wind
fills my marrow
we speak to one another without words
our languages are turns in the light, Lightning flashes, epiphanies
we say, *hello again*
i understand that i do not understand
english does not have words for Who it is

sometimes someone calls my name
same as my mother: *anna gracia!* ▮
as if she's returned from that other place, inside a fugitive Wind
broken Free Wild-Hearted
always, i turn to look. a Bird in a Maple, a Frog after Winter
dark Shadows running between Alders. something or Someone
who has been alive from the beginning of time
with Wings like an enormous Owl, sweeps

a distant memory, a memory who comes
closer the more we see one another
as a Rose must recall herself from centuries ago
when opening every Spring

Q: *have you ever had seizures?*

Deep Bay Night, even in august was terribly Wet and Cold from
the recent days when we had the shivers
wrapped by my dead uncle's Cowichan sweater
made for him in 1942
it is full with wish Thanks and Prayers for Thunderbirds

Tent, Shake, Bell Ring, Salt bodies dark Air
i could see and feel and hear, from where i stood
in my friend's Bear Lodge
different Bears came in, no, men dressed as bears
no, Bears. the last Bear, he came in singing, being
all became very hot, all was closing in and spinning, Whirling
i recall eating Grass

Ursa prophet received a blast from Heaven
Branched Broken Lightning, threw my quaking body down as a Swirling pool
i saw ██████████████████████████████████████
i woke up eating wet Grass, *maw maw*
a man made Smoke, beat a Wing fan
Green Flowers gently brushed across my face
come back, come back, he said, but it was so too hard to
come back

my feet covered in Dirt, bare, as if i had been doing but not doing
my shoes, socks, brought to me by a man, from the
opposite side of the Roundhouse
i never found my sweater or my scarf
these our wonderful Lives

Q: *have you ever seen things, things that no one else can see?*

no. i mean yes. if everyone saw these things, we would all be
housed, fed, taught, Safe, sane, Loved Beloved

see, feel, with/among strangers, Friends, Trees, Animals
why do we humans talk so mercilessly, why do we smell so ruinous?
why do we want to break it all apart?

this, unbearable. i hide

Ghosts, Spirits, SuperNaturals (anyone can see them)
Black amorphous Runners caress door frames
opaque Beings expand from hallways
who are you? they may respond with hands, slams, startlement

knocks from inside walls, upside-down heavy-heeled walkers, moving curtains
doorknobs turn, turn, music as if far away, smoke
from a Volcano with its melted Granite smell
such trivialities, so simple. please don't tell a soul

she had asked so i had made an Amulet from
a Whale's tooth, a Blue bead, a bit of Sinew
in the office, a Vision of Flames around a sparsely bearded human face
Yvonne claimed him as her long-gone Uncle whose Spirit Helper was/is Fire

Animals made of Mist, crossing, dancing on Desert highway in dead of Night
funny, i never thought i'd see a White Hen, White Turtle, White Monster
do you see them? i asked Sylvia's mother, as she drove on, her head
fallen to her chest Sylvia shouted *wake up mama!*
Baja heat, dead of night, driving North, driving South. we were looking for our
Beach, where the Water is as warm as a bath

fully Black Sasquatch, River stands, watching Space towards another
setting Sun Shore, transfixed, aware, on duty
silent as his Wild Mountain Rock Boulder Home

Ermine watches Mice frolic inside
staked Ocean Stones
dark-eyed no-nonsense meat eater

Glowing Green Diamondback Rattlesnake, thick as a thigh
impossibly long, rustling Leaves as he passed in front of us, between Giants
Sequoias. Sarah saw him too, but when we told our fellow campers not a one
believed us, although we were among other folks who say, *Love Nature*

SuperNaturals in the Forest, in the multiColoured Sky, in Soil
people without shelter, stray Dogs, road Dirt, Cats
need for a kind word. alleyways, roof jumpers
shivering, thin coats, huddling

Land, Beings, murdered, eternally (no where to) return
missing and massacred beings, ancient Forests on flatbed trucks

anyone can see them, they say no

everyone sees them, but still say no
sufferings, Fantastic Beings, invisibility

Q: *do you feel you are on a mission, like a mission from God?*

Creator/Spirit (place your Name here), Nature, Rights, Responsibilities
Liberationists, from the Roots, Workers, Hermits, Monks, and Clowns
reformed or otherwise, our catechism, manifesto
HomeLand! Earth! Beings! Justice!

why or how would anyone have a reason to arise every day
without these impossible tasks?
impossible? invincible!

hungry, growing Food for others
humble gatherers of overstock, day-old Bread, fallen Fruit fill a Foodbank
Lovers, of/for all Who live
those who lay it down, stand others up

Miracles are returned to the Original instruction for all to Thrive –
shared meals, full-stomached Bears, flowing Streams full of lives, Loves
inaccessible Treed, Rocked, Iced, Grassed, Flowered temples of Holies
unanswerable requests, Golden and Blue Spruce, White HoneyBees
fistful of Seed laid out for a Gull
hand-Holding Breath

Q: *do you worry excessively about the future, do you feel hopeless about
the future?*

this is what it looks like to give a damn
the cost one pays freely

pain, struggle, validation
Love for all Living Beings
Thanks for to all Living Beings
ThanksGiving is every hour of every day

Q: *when you don't hear from someone, do you obsessively imagine they are in the
hospital or have been murdered? do you always fear the worst?*

my Mother's village is a Home
destroyed by soldiers, long ago

Q: *do you imagine the law is against you, that they are watching you?*

my Grannies Uncles are arrested in Forests

bodies heaped in a well, a church sanctuary full of Gardeners
set alight

Marc's vow of poverty, lost teeth, the Catholic Worker Movement
Good Friday Hail Mary Rosary, federal prison consequence
Jesus said, *feed the hungry*. police arrest sandwich givers
Home the houseless, collect RainWater, waffle Garden paradise

time, lust, training and planning to kill us
two-thousand-year-old Trees
clear-cut loggers pose, smiling at their extinctions
they starve our families, collapse
Mothers' final StrongHold
Who shall offer shade, nest Holds, or Dirt Held

Indian residential school graveyards now revealed
see me
our gaze turns to empire
there are other ways to be

massacred, murdered, imprisoned
hunted, tortured, vanquished
missing, maimed, dispossessed to
inner-city wreck, downfall

Land, her Beings, Land Defenders, beaten, arrested, murdered
my grannies, my niece and nephew, handcuffed, disappeared
JJ and his compatriots beaten by police at Home, maimed by jailers
survivors surveilled. a helicopter tracks locates shoots

Indigenous Peoples' Living HomeLand
Land Defenders Protect our every Lives
the Cold, hard Ground, jail cell, tomb is Our Love
Responsibility to Home House Earth

Q: *do you receive special messages from everyday things?*

yes of course!
(she gives me that look)

Q: *what do you mean?*

from Bears, Winding Winds, Clouds

she says, *no, like the tv*

as if i would talk about St. Anthony hiding things and replacing them
Dreams of the future
language i can't understand
is anyone thirsty, can anyone explain
the healing Power of a Spring

notes from counsellors (indoctrination)

it starts before we are born, this
Ceremonial everyday sight. others of all shapes carry/ied it
to and fro It is sent back again
as are Bees, with every newBorn Being. this the reason for
Spirit Flowers, Soul Dust, Shimmering Water
Salt Woman, Squash Woman, Old Man Grizzly Wolf

an impossible journey – from Visions to forced Witness
clear-cut, trophy hunt, cruelty meat –
Sacrifice, Prayer, Work

kill yourself (no!)
my employer has counselling available to employees
they picked her especially for me with excellence
specificAlly for Indigenous persons
she is forever right, she said, as she has once been in a Sweat Lodge
asked about what she called, hearing things, seeing things

Mary yells – Protection of an older Sister
> *never tell them of Ghosts, Visits, their Powers*
> *they won't believe you and they will tell others you are nuts*
> *how dare they hurt our cherished Family*

interchange interface of here, there, every Being Where
i dug deep to briefly trust/tell this Glorious reality

ii. easily erased

Q: *those Voices in the Lodge come from your fasting brain, that is all it is, the brain firing from lack of Food and Water, science has proven it, so get with it, dummy, and don't worry, you are not nuts*

i had been Blessed, i had been spoken to, as i had prepared to be
all the days of my life
i dwell in the House of Butterflies
carcasses, suffering, forever
because this life is

counsellor told my Mother's tired face
 you think more than you feel
i think i held my weakened broken body upright
feeling half dead

another therapist said
 you are against whites (i am half beLoved father)
when i advocated Rights, Indigenous persons, Beings, Land
and noted hunger, suffering, state-sponsored murders maim

Wild Horses are rounded up by helicopter and slaughtered
Campesinos herded together, butchered by armies
cabins, entire villages burned to the ground by police for hydro, pipelines

murder of the innocents
extinctions, red list is a Red list
climate refugees

i would have beseeched, i would have cried out
but i knew (there is no such thing as understanding among the experts)

long ago a beLoved teacher said, *all Maya are extinct*
i then begged Auntie to cut my Braids

we have Visions in these times
we have Power in these times
i wait for the Blessed Ones to fix all of this
the ones who truly know –

rise of the Moon
the incoming Tide
the Cold

abduction

what is it differs, you, i
you are paid, i am Free. money is the only
bridge join union you ruin plastic microbeads
Whale belly Bird beak open up we are full
of no nourishment – bottle caps cigarette ends

i Cry for Rain. Fast for the last of gorgeous
enormous Elder
Forest Understory Underground. Soil is Life
place myself in the path of certain Star Beings
go without
this is all an empire's arrestable offence

printed paper's enchantments charm you into
breaking my wrist, tying my arms behind my back
there are over one thousand, billions of us
Whom you abuse today
as we recall the many hundreds of thousands
millions in their Graves, handcuffed

your paper amulet has erased your name and you are only now
an abuser, blood-letter, bone breaker
whose patch do you wear?
whose. no one shall name that two letter this four letter as they
are the same morgue

my body is limp, i am inside a hole. i should have eaten so much more so i
would weigh more for you to lift, but i have no more of me to burden you
there are We atop Trees in the form of Snowy Owls
we do more than watch

your fists want our teeth, our eyes
our Blood is the River Water of Salmon-Birthing Streams
we are made of our Sacred drink
we may turn to Salt, come back as Rain

our Blood makes Life, and marks you
you, self-made for eternity, as Fish Souls know to return Eternally
our Moon, exactly as a distant Planet makes oblong Stardust in the Sky
you, papered man, are the missing clue
to our missing, murdereds, courts, starlight tours

the chatter of a Forest, from Crawling EarthWorms to calling Herons
meditative silencing by heavy Rain and brilliant Snow
fallen Majestics sonic boom shake loose Soil
Clouds witness and vow to never
return

Notes

me because of you, 2021. Monoprint. 5" × 5".

Líl̓wat Ucwalmícwts orthography here is from Kicya7 (Dr. Joyce Schneider), in consultation with Mámaya7 (Lois Joseph) and Kakúsa7 (Mary James), and Elder fluent speakers Saẁt (Martina Pierre), Saẁt (Veronica Bikadi), Xázil (Priscilla Ritchie), Léli-lot (Laverne Paul), Lem̓xátsa7 (Morgan Wells), and Tsínaẏa7 (Georgina Nelson). Also consulted: the First Voices' Líl̓wat Home Page (www.firstvoices.com/explore/FV /sections/Data/Sťáťìmc/Lil'wat/L%C3%ADl̓wat), the *Líl̓wat Ucwalmícwts Dictionary* (Mount Currie, BC: Líl̓wat7úl Culture Centre, 2013), and Holly Bikadi for the Southern Stl'atl'imx Health Society, *The Nťákmen Calendar* (Mount Currie, BC: Southern Stl'atl'imx Health Society, 2020). This orthography is used for words of Sacred Home-Lands where i am in Love with Mother Earth, expressed here in solidarity with Land Defenders of the Líl̓wat and other Indigenous Nations of Mother Earth, especially those named here from/with other Nations of all diversities (including non-humans) and those in the Spirit World.

The few Maya words here are from online sources, as i am not a speaker of my family's heritage languages. I am too ashamed to ask heritage language speakers for help.

Ada'itsx (Fairy Creek in English), which first appears in "i saw you" (personals column), is a name for a momentous RainForest within the Huu-ay-aht, Ditidaht, and Pacheedaht Indigenous Territories. Home to some of the last of the Elder Yellow Cedar and her many Forest Beings, Ada'itsx is at this moment under siege by clear-cut loggers, BC politicians and their armed police, corporations, and others who contribute recklessly to species extinctions, climate disruptions, ruin, and violation of the Rights to Life and Lives.

A7xa7 is defined and shared here from Yaqalatqa7 (Johnny Jones).

Ayotzinapa 43 refers to the forty-three young men attending the Ayotzinapa Rural Teachers' College in Iguala, Mexico, who were preparing to become teachers to rural, Indigenous, poor communities, and who were kidnapped and disappeared by police/state/criminals. They have never been recovered, and are believed to have been murdered, their remains burned. Families repeat – *Alive you took them, alive we want them returned!* *¡Vivos se los llevaron, vivos los queremos!* Gratitude to Melissa West and Stephanie Martin for creating *Printmakers for the Ayotzinapa 43*.

Emma is my auntie, ninety-nine years old at this writing.

In "citizenship," **ḱátlaż**, the Ucwalmícwts name for the plant known in English as devil's club, is from First Voices, www.firstvoices.com/explore/FV/Workspaces/Data/Stát̓imc /Lil'wat/L%C3%ADwat/learn/words/4c6a1d68-c63a-43cc-ba00-e00751f930ea.

"Land is a Halo" was read aloud with community at the twenty-second anniversary celebration of Sutikálh in 2022. Love and Thanks to community, Sutikálh, Land Defence forever.

Marc is Marcus Blaze Page, a member of the Catholic Worker Movement, of Indigenous descent.

"The Protein in Wild Meat" in "citizenship" refers to a definition for a man's Indigenous Name, taught to me by his wife, and used here with her permission. Thank you KC, 2022.

Robert is Robert Pictou, Mi'kmaq.

s7ístken, in "Make Real our Inherent Sacred Righteous Rights," is a pit house. Words in italics in this poem are recalled directly from public speeches, social-media posts, in-person conversations, and other formats by **Kanahus Manuel** (daughter of Arthur Manuel, the son of George Manuel).

Sleydo' (Molly Wickham), Gidimt'en Clan member, is originally from the House of Spookʷ, adopted into Cas Yikh (Grizzly Bear House).

Starlight tours is the name for the deplorable police practice of driving Indigenous people to the countryside outside the cities they live in and leaving them there, often in freezing temperatures, frequently even removing their clothing. Many people have died as a result of this crime, which continues to this day.

Sutikálh is Sacred Home to the Winter Spirits in Líl̓wat Territory.

Sutikálh Hubie is Hubie Jim (Land Defender).

In "not lying down," **this hearing** refers to the National Inquiry into Missing and Murdered Indigenous Women and Girls.

Tsemhuqʷ refers to "Chubb" Harold Pascal (d. 2001), Life Partner of Lahalus Loretta Pascal.

Yaqalatqa7 refers to Johnny Jones, Líl̓wat.

Acknowledgments

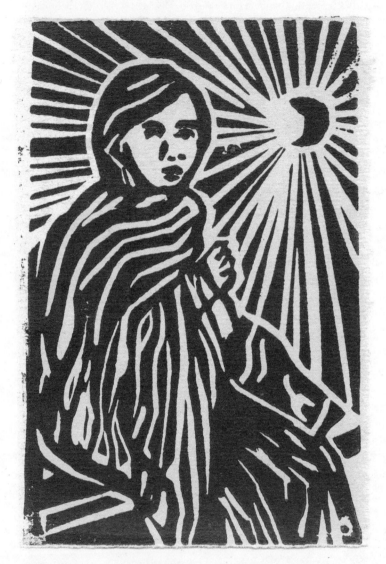

wrap, 2021. Relief print. 2⅓″ × 3″.

Thank you all, every Wild Sacred and Good, may you Live Forever.

Thanks to all Loving honest hearts who in every way every day knit it all back together.

Thank you Kicya7 for the orthography of Ucwalmícwts words.

Thanks to the editors of the journals and books where some of the poems included in this book first appeared: a version of "Wild, Sacred, Good (Vine Maple)" appeared in *Sustenance: Writers from BC and Beyond on the Subject of Food*, edited by Rachel Rose; "*A7xa7*" is reworked from an article originally published in the *Canadian Geographer*, invitation by Dr. Nadine Schuurman; and "Fish" first appeared in an earlier form in the *Capilano Review*, edited by Matea Kulić.

Thank you, artist and collaborative printmaker Val Lowen, for running the accompanying print series *some people fall*. Thank you everyone at Malaspina Printmakers, Vancouver.

Thank you Spencer Williams for photographing the prints for publications. Thank you Leslie Smith for the layout and cover. Thank you Catriona Strang for editing, friendship, care, and the phrase "salty mama." Thank you everyone at Talon, Kevin Williams, Vicki Williams, Charles Simard, Leslie Smith, Darren Atwater, and Erin Kirsh, for being a great team and for bringing work forward from many diverse voices.

annie ross (Maya/Irish) works with/in communities and is in Love with Mother Earth and all of her Beings.